SEURAT

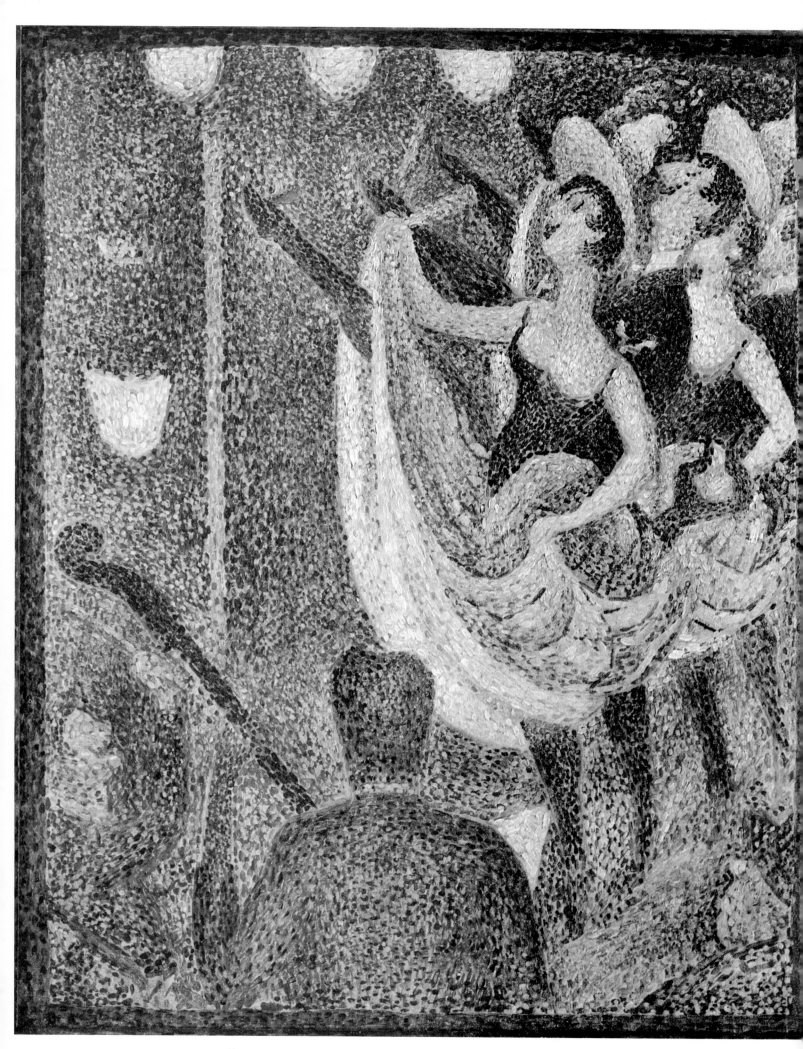

FINAL STUDY FOR "LE CHAHUT." 1889. Oil on canvas, 22 × 18 1/4". *Albright-Knox Art Gallery, Buffalo, N.Y.*

GEORGES

SEURAT

PIERRE COURTHION

HARRY N. ABRAMS, INC., *Publishers*, NEW YORK

Translated by Norbert Guterman

The quotations from C. K. Scott Moncrieff's translation of Marcel Proust,
Remembrance of Things Past (*The Guermantes Way*) are reproduced
by courtesy of Random House, Inc., New York

Library of Congress Catalog Card Number: 87-73460
ISBN 0-8109-1519-7

Published in 1988 by Harry N. Abrams, Incorporated, New York.
This is a concise edition of Pierre Courthion's Seurat,
originally published in 1968. No part of the contents of
this publication may be reproduced without the written
permission of the publisher.

A Times Mirror Company

Printed and bound in Japan

CONTENTS

ACKNOWLEDGMENTS

FOR DATES AND DIMENSIONS I have in nearly all cases followed the indications given by César de Hauke in his monumental *Seurat et son oeuvre*, 2 vols., Paris, 1961.

An extensive bibliography to 1959, as well as a list of major Seurat exhibitions, can be found in Henri Dorra's and John Rewald's *Seurat*, Paris, 1959, to which I referred. Valuable additional data on Seurat's drawings are contained in R. L. Herbert, *Seurat's Drawings*, New York, 1962.

I should like to express my gratitude to everyone who assisted in the present work, particularly to Madame Claude Corpechot and Madame Pierre Astier, grandnieces of the painter; Monsieur Cassanas, General Secretary of the École Nationale des Beaux-Arts, Paris; the supervisory staff of the Archives de la Seine et de la Ville de Paris, which sent me a photostat of Seurat's birth certificate; and the Chef de l'État Civil de la Mairie du Xième Arrondissement for excerpts from the painter's death certificate. Lastly, I want to thank Monsieur F. Roussel, Secrétaire Général of the *Mairie* of the Eighteenth Arrondissement and the Juge Directeur of the same *Mairie*, who helped me obtain a complete copy of the birth certificate of Seurat's son, and Madeleine Knoblock's declaration of maternity.

Seurat

Georges Seurat is not easy to know, either as an artist or as a personality. Yet, to know little or nothing of his life can hardly detract from our appreciation or understanding of his highly deliberate painting, for his is a self-sufficient art, which is to be understood primarily in terms of its formal and plastic qualities.

Seurat's entire artistic career is compressed within a dozen years, but a great deal of study, research, and hard work was crammed into this period. At his death he left behind only four very large paintings and a fair number of smaller canvases, oil studies, and drawings. Their quality is great enough, however, to arrest us, to make us feel that we are indeed in the presence of a master.

"Imagine a tall young man, extremely shy yet of great physical energy, with the heart of an apostle and the gentleness of a girl. His voice is low, muffled, persuasive. He is one of those peaceable yet stubborn men who may appear afraid of everything, but who actually do not flinch at any challenge. He worked with incredible intensity, shutting himself up like a monk in a little studio on the Boulevard de Clichy, doing without creature comforts, using his scanty means to buy expensive books instead. At this time he was trying to show that his very interesting theory about painting outdoor subjects was applicable to large figures in indoor settings, and it was now that he painted *The Models*."

This was Arsène Alexandre's portrait of Georges Seurat at twenty-eight. He was in marked contrast to the flamboyant personalities of the period, and all who knew him remarked on his seriousness. "That one never did anything on impulse," said an acquaintance.

Seurat was a man of few words. "His was an extremely withdrawn personality," Charles Angrand, a companion of Seurat's artistic struggles, tells us. "All that really stood out in it was the artistic factor." To make him climb down from the stepladder on which he perched in front of his canvas, working in silence, his eyes half closed, a wooden pipette held tightly between his teeth, friends sometimes started arguments about his theories. This would bring him to attention, and soon he would be outlining his ideas in

Photograph of Georges Seurat

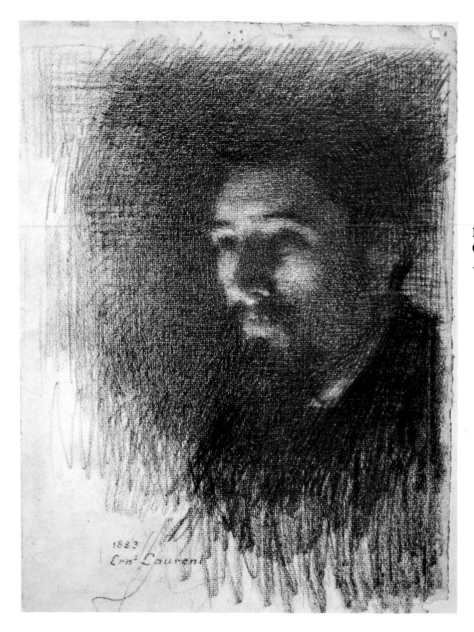

Ernest Laurent. SEURAT. 1883.
Charcoal, 15 1/4 × 11 3/8".
Musée d'Art Moderne, Paris

detail. Taking up a piece of chalk, he would begin to draw on the studio floor—David-Pierre Humbert de Superville's diagrams of gay, indifferent, and sad lines, or David Sutter's geometric analyses, or Eugène Chevreul's color wheels.

Lucie Cousturier—an artist friend of Seurat's and one of his earliest biographers—describes him in a well-tailored jacket, wearing a white polka-dot tie and looking even more like the floorwalker of a department store than did any of the chic artists of the period. She also speaks of his "velvety eyes" and of his black eyebrows, which were frequently lifted. With his straight nose, heavy eyelids, and high forehead he was a handsome young man.

When not working, Seurat liked to take long walks. One of his friends describes him—in the Decadent literary style of the period—walking, "as often at dawn as at twilight, along the streets of the famous city spoken of as Paris, sometimes going as far as Barbizon, with his long narrow case of colors in his hand." Degas called him "The Notary" because, Gustave Kahn tells us, "he would saunter slowly along the outer ring of boulevards from the Place de Clichy to the Boulevard Magenta, very properly dressed and wearing a top hat, arriving at his family's place punctually in time for dinner." Mornings he would stop work just long enough for a quick lunch at the nearest restaurant, "wearing a short jacket, with a narrow-

brimmed felt *caloquet* jammed down on the back of his head."

The earliest portrait drawing we have of Seurat is the one in charcoal by Ernest Laurent, Seurat's fellow student at the École des Beaux-Arts. Evenings, the two often worked by artificial light. It was on such an occasion that Laurent drew his friend for *Scene on the Bank of a Brook*, a pictorial commentary on Beethoven's *Pastoral Symphony*, which the two had heard at the Concerts Colonne. (According to Paul Jamet, Laurent exhibited a canvas of that title at the Salon of 1884.)

A later portrait, dating from 1890, is a lithograph by Maximilien Luce on the cover of *Les Hommes d'aujourd'hui*. His features in profile enlivened by absorption in his work, the artist is shown in front of a canvas, applying those countless dots which were then so widely criticized but which he could make vibrate with light and color. In the same year Luce also made a watercolor showing his friend in three-quarter view, examining a sketch with restless eyes. The face is that of a worrier, of a sixteenth-century Huguenot.

This was the solitary worker whom Émile Verhaeren, his elder by a few years, called upon in the Boulevard de Clichy studio. "Quietly, sparing of gesture, never taking his eyes off you," the Belgian poet tells us, "his slow even voice picking out slightly pedantic words, he would point out the results he had achieved, the things he was absolutely sure about, what he called 'the basis.' Then he would ask you questions, make you say what you thought, waiting for you to say the word that showed you had understood."

Of what went on in his head when he was alone, we know nothing. He was all self-restraint, dignified reserve. He concealed his love affair with Madeleine Knoblock from even his closest friends so effectively that only after his death did they learn that Seurat had had a mistress, that she had borne him a child (a boy whose birth had been duly registered at the *Mairie* of the Eighteenth Arrondissement, his name given as Pierre-Georges Seurat). The boy died shortly after his father, having caught the same infection. As for Madeleine, two members of the Seurat family,

Madame Claude Corpechot and Madame Pierre Astier, say that she was Alsatian and that she disappeared without a trace. It seems quite possible that Seurat met her at the time he was painting *The Side Show*, near one of those traveling carnival booths shown in the picture. *Young Woman Powdering Herself*, Seurat's painting of her, is redolent with that atmosphere.

GEORGES-PIERRE SEURAT was born in Paris at 60, Rue de Bondy, in the Fifth Arrondissement, on December 2, 1859, at 1 A.M. His father, Antoine-Chrysostome, a native of Champagne, a bailiff at La Villette, was looked upon as an eccentric, a man given to foolish fads. Gustave Coquiot tells us that he collected holy pictures put out by the Mame publishing house and dark-blue Épinal prints of St. Nicholas. On Seurat's birth certificate Antoine-Chrysostome, aged forty-four, is listed merely as "property owner." It is known that Seurat's father escaped from the family circle in the

Maximilien Luce. SEURAT. 1890.
Lithograph. *Courtesy Bibliothèque Nationale, Paris*

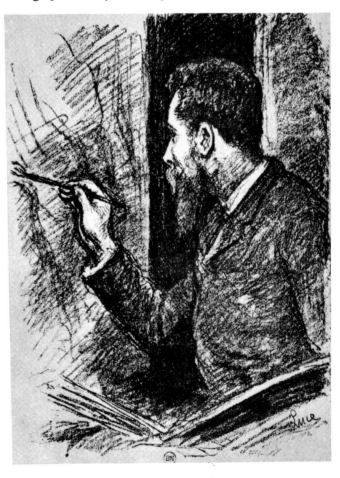

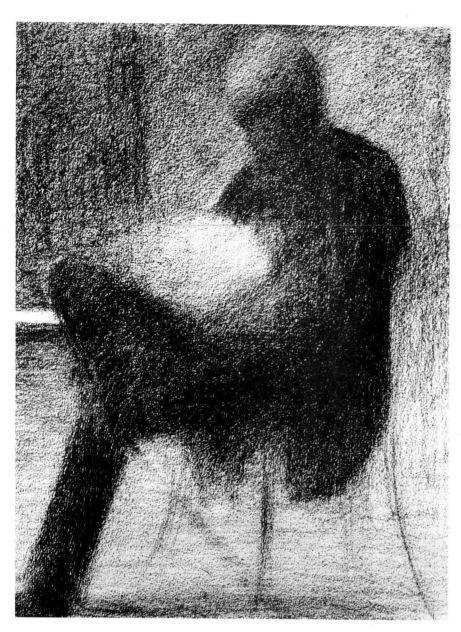

THE ARTIST'S FATHER READING
ON A TERRACE. C. 1884.
Conté crayon, 12 1/8 × 9 1/4".
Collection Mrs. J. C. A. Roper, Paris

Boulevard Magenta whenever he could, taking refuge at Le Raincy, where he had a house with a tiny garden which he looked after with great pride. According to Robert Rey, he had some sort of chapel set up there, in which he said mass in his own fashion, assisted by his gardener. Georges Seurat felt less close to this whimsical man—who would come home every Tuesday—than to his mother. Born Ernestine Faivre, she was a Parisian of the lower middle class, thirteen years younger than her husband.

Brought up in this modestly well-off family (during the Paris Commune, when Georges was twelve, his parents prudently fled to Fontainebleau), Seurat pursued the usual course of study in one or another *lycée*.

Once attracted to painting, he did not at first follow in the footsteps of the innovators. Turning his back on the rebels of the day, the Impressionists, he got his start in 1875 at a drawing class sponsored by the municipality, turning out endless drawings of noses and ears from lithographed models under the supervision of the sculptor Justin Lequien, in the Rue des Petits-Hôtels, a few steps from his own lodgings. There he met Edmond Aman-Jean, with whom he used to go to the École des Beaux-Arts, where they practiced drawing from plaster casts. In its galleries and under the enormous rotunda where the copies of classical statuary were crowded together, Seurat made careful drawings in lead pencil or charcoal,

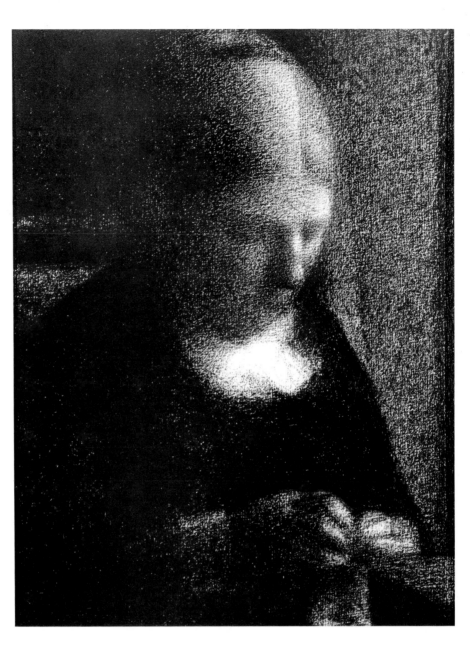

studies of torsos and drapery, such as *The Discus Thrower* and *The Calf-Bearer*. After passing the preliminary examinations in February, 1878, he formally entered the École the following March 19th, in the studio of Henri Lehmann, a pupil of Ingres, whose own superacademic works usually included a great number of clouds.

Studying under Lehmann, Seurat worked mostly by and for himself. Evenings, when the model had left, he would climb the great staircase to the library and go right on working. Here he rediscovered a book he already knew (he had read it while still at the *lycée*): the *Grammaire des arts du dessin*. The author, Charles Blanc, believed that once colors were understood as

obeying consistent rules, color theory could be taught just as surely as the theory of music. Under Blanc's supervision, a painter named Loyoneux had made copies of Piero della Francesca's frescoes at Arezzo, which were placed in the chapel at the École des Beaux-Arts. As Roberto Longhi has noted, Seurat was greatly influenced by these transcriptions, which opened his eyes to the Italian primitives, though what he saw in them was not what the Pre-Raphaelites had seen. In a linear style he drew figures of Oedipus and a sleeping shepherd. He copied a portrait by Holbein, drew Nicolas Poussin's right hand (from Ingres' *Apotheosis of Homer*, which was in turn inspired by Poussin's self-portrait in The Louvre), and painted a

13

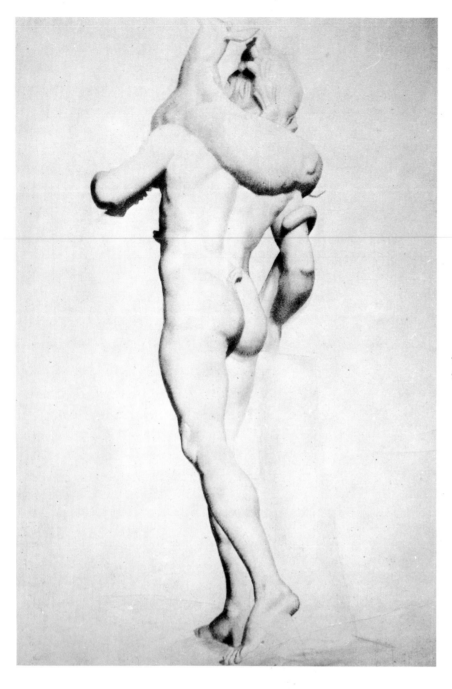

THE CALF-BEARER. C. 1876–78. Charcoal, 24 3/8 × 19". *Private collection, Paris*

detail from Ingres' *Roger Freeing Angelica,* which shows Angelica chained to the rock.

With Aman-Jean and Ernest Laurent, fellow students—the former a painter of colorless pictures, the latter more sensitive but too ready to compromise —he attended the Impressionist exhibition in the Avenue de l'Opéra in the spring of 1879. There he admired the paintings by Degas, Monet, and Pissarro. Disheartened by the icy academicism of their teacher, the three friends jointly rented a studio in the Rue de l'Arbalète near the Jardin des Plantes. They shared the admiration of most young artists of the time for the barren simplicity of Puvis de

Chavannes and Gustave Moreau's "flowery hieraticism."

In November, 1879, Seurat went to Brest and served as an enlisted man for one year, fulfilling his obligatory military service. Returning to Paris, he moved to a studio furnished with a couch and a few easels, at 19, Rue de Chabrol.

Now all on his own, he set out to complete his artistic education. He was influenced to an unusual degree by technical treatises. Aware that painting addresses itself to the eye, he investigated optics with a thoroughness not known since the studies made by the Renaissance masters. A student of ge-

ometry and physics as well, he came across Chevreul's *Atlas* one day, and pored over the color wheels illustrating the full range from pure tones through successively weaker gradations of intensity to the stage where they lose their distinctness. He read another book by the same author, published at Dijon in 1864, in which Chevreul wrote that the fine arts "feed us only on abstractions, even when, as in painting and sculpture, they present the viewer with a work that reproduces the image of the concrete." The great chemist observed that "to apply a color on a canvas is not merely to color the part of the canvas on which this color is applied, it is also to color the surrounding space with the complementary color." And Chevreul names the Duc de Saint-Simon, the memoir writer, as the master sorcerer in the use of simultaneous color contrasts. In support of the assertion he quotes Saint-Simon's verbal portrait of the Duc d'Albuquerque: "I saw right in front of me a squat, ill-proportioned little man in BLOOD-RED coarse-cut clothes, with buttons of the same cloth, and greasy GREEN hair falling to his shoulders."

Chevreul opened up to Seurat the full gamut of complementary colors (he had already seen Delacroix' efforts along this line in the Saints-Anges chapel at Saint-Sulpice). But it was Humbert de Superville—the painter and engraver who had made important studies in Rome and had been in charge of the Print Room at Rotterdam—who was to provide him with his rules of expression. In his *Essai sur les signes inconditionnels dans l'art* (Leiden, 1827), Humbert demonstrated that scientific rules cannot possibly act as a check upon the spontaneity of invention and execution. According to him, harmony comes about when the "human I" and the "non-I" are in tune. "All of us feel the need for transmitting signs to the soul by way of the eyes." "Lines speak and signify."

In David Sutter, a native of Geneva who had given a free course of lectures at the École des Beaux-Arts and published studies on "The Phenomena of Vision" in the magazine *L'Art* (1880), Seurat found a development of Humbert's ideas applied to the analysis of paintings according to a geometric schema of Sutter's own, and to the study of proportions. (It

was the influence of Sutter's proportional system that was to lead Seurat to paint the borders and frames of his paintings himself.) Further, he delved into James Clerk Maxwell to learn about the electromagnetic properties of light, consulted the works of Dove and Helmholtz, copied out the "luminosity equations" and the color wheel published by the American O. N. Rood in his *Textbook of Color* (New York, 1881), and discussed "dynamogenics" with Charles Henry, librarian of the Sorbonne and former laboratory assistant to Claude Bernard.

Steeped in these theories on color optics and the significance of line, Seurat summed them up when he dictated the following precepts to Jules Christophe. They are rightly regarded as his artistic credo:

Art is harmony. Harmony is the analogy of opposites (contrasts), the analogy of similar (gradated) tones, hues, lines. By tone is meant the range from light to dark; by hue, red and its comple-

PROMETHEUS. C. 1877. Charcoal, 26 1/2 × 19″. *Private collection, Paris*

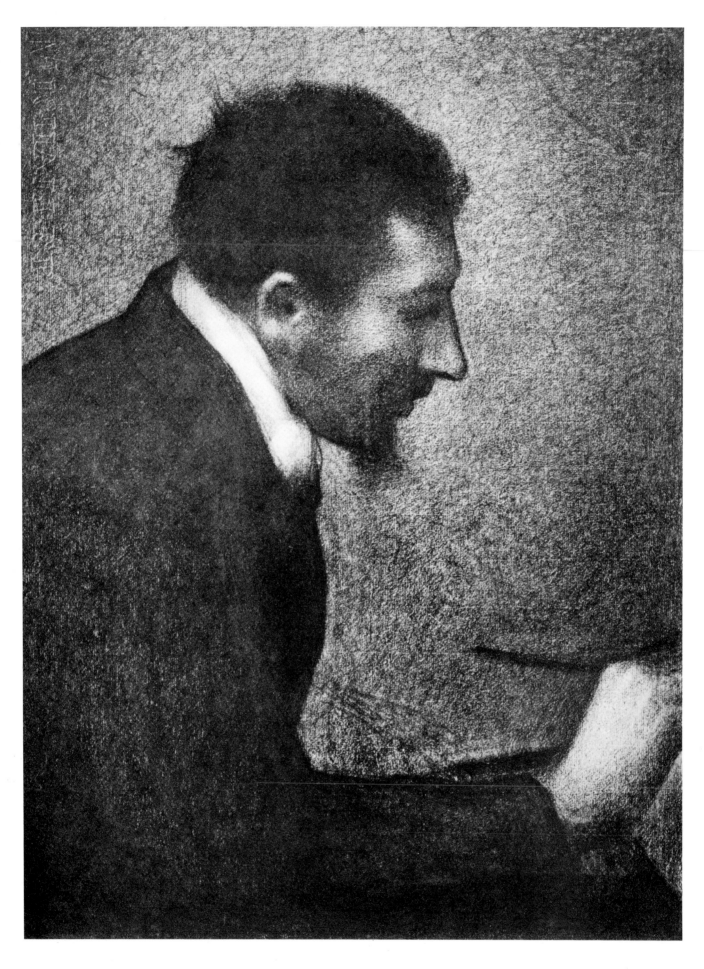

EDMOND-FRANÇOIS AMAN-JEAN. C. 1883. Conté crayon, 24 1/2 × 18 3/4″.
The Metropolitan Museum of Art, New York. Bequest of Stephen C. Clark, 1960

MALE TORSO. C. 1877. Pencil, 9 3/8 × 11 5/8".
Private collection, Paris

As in the case of his friend Angrand, we might be able to make out Near Eastern or Oriental influences on Seurat, something picked up from Sumerian or Khmer sculpture. According to Françoise Cachin he copied out a treatise by a Turkish poet which urged painters to work from the light to the dark, not the other way round. Seurat nonetheless followed the precepts of Corot, to whom he owed his magic touch with gradated values, and whose advice was the opposite of the Turkish poet's.

So, dreaming of an art less broken up than that of the Impressionists, unwilling to become a recorder of fugitive sensations tracking down seasons and times of day in the throbbing reflections of a changing,

mentary green, orange and blue, yellow and violet; by line is meant the indications of direction on the horizontal. These divers harmonies may be combined to produce serenity, gaiety, or sadness. By gaiety of tone is meant that warm tones dominate; by gaiety of line, ascending indications of direction (above the horizontal); by serenity, that there is equality between dark and light tones, between warmth and coldness in hues, horizontality in line. By sadness of tone is meant that dark tones dominate, by sadness of hue that cold hues dominate, and by sadness of line that the indications of direction run downward. The means of expression is the optical mixture of tones, hues, and their reactions (shadows) in accordance with perfectly fixed laws.

Taking Delacroix as his point of departure, Seurat at first experimented with mixtures obtained not on the palette but optically on the canvas or panel. Had not Ruskin already advised, referring to Turner, that one should apply the living colors in small dots on the other colors or in the spaces between them, and carry the principle of separated colors to the utmost possible refinement?

Schema from David-Pierre Humbert de Superville,
*Essai sur les signes inconditionnels
dans l'art*, Leiden, 1827

17

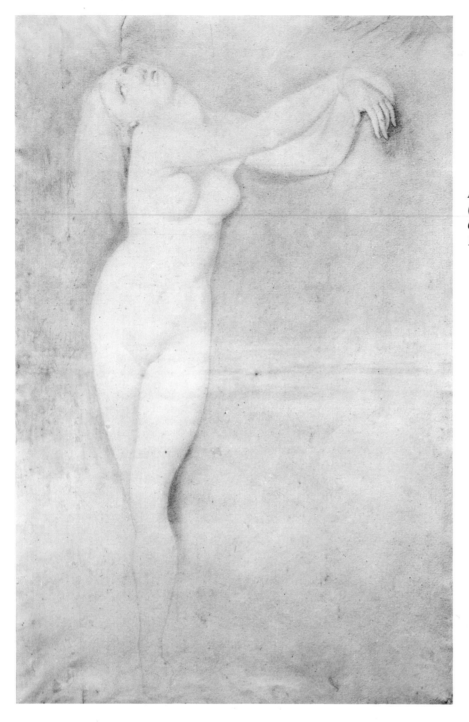

ANGELICA CHAINED TO THE ROCK
(after Ingres). 1878. Pencil, 17 × 11".
Collection Mrs. Jacques Lipchitz,
Hastings-on-Hudson, New York

disembodied nature, Seurat gradually evolved an art of his own. A painter of the instantaneous view, he knew he would have to pick out one given moment from the rest and envisage it as a true abstraction from the sum of moments constituting the event he had chosen to evoke. His self-appointed task would be to extract the eternal moment from the passing flux.

Further, going back to studio painting, which the Impressionists scorned, he rediscovered the concentration propitious for creating an art of synthesis.

Those fluid, shifting streaks of color wrested from living, breathing nature he rigorously organized in the form of dots of divided colors. Anxious to recover the guiding lines of composition in his pictures, he broke them down analytically, treated them as things apart from the image they were supposed to reproduce, the better to bring out their plastic significance. With Seurat, the painter—for some time removed from his own pictures—comes back to his post at the very center of their creation. Turning his back on chronological time, the uniformly common

measure of events, he puts the artist back into the very heart of the work, which he proceeds to turn into one vast synthesis: *Bathing at Asnières*, with its fresh, clearly organized treatment of line and color, heralds the Synthetic style.

Two NEW TRAILS were being blazed in the domain of the arts in that period: one by Gauguin, who was about to travel to distant places in search of a paradise unspoiled by civilization, and one by Seurat, who wanted to make everything over for himself. Both Gauguin (who dreamed of achieving a "Puvis with color") and Seurat (who felt that Puvis de Chavannes was restoring construction to painting) began as fervent admirers of the artist from Lyons. In their view—they did not perceive the poverty of his symbolism—Puvis, painter of the decorative *Peace* and *War*, and of *The Poor Fisherman*, was rediscovering the laws of composition which the Impressionists had neglected. However luminous and vibrant the works of the latter, they were heading in the direction of formlessness and the evanescent.

Both Gauguin and Seurat were intent upon restoring pictorial unity and order. But whereas the former was about to plunge into an art threatened with folkloric exoticism, the latter succeeded gradually in reconstructing everything from art's inner resources, following a method the rules of which were defined by science, and which channeled freedom and spontaneity without stifling them. It is therefore not surprising that the avant-garde poets and novelists

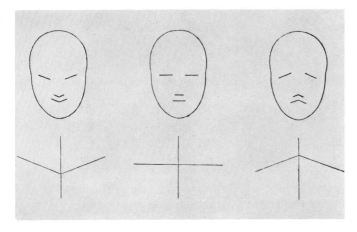

Schema from David-Pierre Humbert de Superville,
Essai sur les signes inconditionnels dans l'art,
Leiden, 1827

of about 1885 took him up. Seurat saw nearly all of those who at the time were called the "Decadents"—Jean Moréas, Paul Adam, Jules Laforgue, Gustave Kahn, René Ghil, Félix Fénéon, Charles Henry—at the Gambrinus tavern on the edge of the Luxembourg Gardens, which was also frequented by the young Maurice Barrès. "Weary of the contemporary quotidian, the trite and the obligatory," as Kahn described them, these fatigued rhymers in search of new rhythms, all admirers of Verlaine, found a kind of ally in this young painter who was reforming the theory and practice of color.

Seurat probably felt pretty much cut off in this small group of friends and mutual admirers, at a time when the painters Bonnat, Henner, Carolus-Duran, and Bastien Lepage were the fashionable celebrities. Although Pissarro was so rash as to tell Signac that Seurat was an academic painter, the truth is that he was on the side of the "advanced ones," like his friends Félix Fénéon and Édouard Dujardin, the latter the deviser of the interior monologue in literature. But he must have had something of a foreboding of the fate that hung over his Symbolist and Decadent friends in varyingly threatening degrees, for he made a point of seeing something of the last of the realists too, as a counterbalance.

What but a Seurat painting comes to mind in the scene in Paul Adam's *Soi*, when Marthe Grellou, the heroine of the novel, is looking at a canvas and marvels at "how greatly these flecks of pigment break up the colors into separate hues? Each one consists of a tiny drop of color juxtaposed with others like the individual threads in an intricate tapestry, the over-all impression produced by the perfect harmony of the tiny spots of color so orchestrated."

Seurat differed from his comrades-in-arms—all of whom were more or less caught up in current fads—by his profound intuition of form in its perennial aspects. Steeped as he was in the modishness of his period, he yet succeeded, Gustave Kahn wrote, in "raising it to the level of style and turning fashion into a sustained equilibrium."

For two years after *Bathing at Asnières*, Seurat was engaged in the almost uninterrupted preparation for *A Sunday Afternoon on the Island of La Grande Jatte*,

STONE BREAKERS. C. 1881. Conté crayon, 12 1/8 × 14 3/4". *The Museum of Modern Art, New York. Lillie P. Bliss Collection*

the large painting to which he devoted himself partly out of doors, partly in the studio. On La Grande Jatte, an island in the Seine near Paris which he visited every week, Seurat was surrounded by the noise of young people disporting themselves in rowboats, dinghys, and canoes, and in sailboats with their sails snapping in the breeze. Gustave Coquiot, the art critic, was often there and recalled hearing cries of "Hey there, Maurice, Boit-sans-Soif [Hollow Leg], hey Bouffe-toujours [Fatty], Cachalot!" These were the boating enthusiasts of the period calling to one another like old familiars meeting in a bar or tavern. The girls in the boats would also call out to one another in the same spirit—nobody was going to call *them* "barnacles."

Today the trees are all gone, but in 1884 La Grande Jatte was a green Arcadia, the meeting place for Sunday boaters and courting couples. With his very agile brush Seurat would draw oil sketches on little panels. Month after month in his studio in the Boulevard de Clichy, working from these notes set down from life, he gradually built up his big canvas on which the strollers and siesta-takers are skillfully spaced, distributed along tree-shaded paths and over the grass, between the chill greens of the shadows and the full brilliance of the sunshine.

Before taking its final place, blending into the unity of the whole, every detail of the composition was worked out in numerous studies. Take, for instance, the woman strolling in the foreground at the

right. We see her successively as a woman fishing with a rod and line, a strolling figure such as appeared in contemporary fashion magazines, and then in the guise of the *dame-poteau* (the "stick lady," who was as "stiff as a gatepost"), with a hat in the shape of a truncated cone, her bust tightly constrained in her dress, and the bustle at her back sticking out to form a real platform or "rumble seat." Lastly, we are given the definitive profile, which Seurat joins with that of the man in the top hat behind her.

When *La Grande Jatte* was exhibited at the Indépendants in the spring of 1886, its effect was that of a manifesto. "The two schools that reigned at the time," Paul Signac wrote, "the Naturalists and the Symbolists, each judged the painting from their own point of view. J.-K. Huysmans, Paul Alexis, and Robert Caze saw it as a Sunday spree of drapers' assistants, apprentice pork-butchers, women looking for adventures, whereas Paul Adam saw the rigid figures as an Egyptian frieze and the Greek-born Moréas hailed the work as a Panathenaean procession. Actually, all Seurat intended was a clear, cheerful composition of well-balanced verticals and horizontals with warm hues and clear tones dominating, the most luminous white at the center. Only the infallible Félix Fénéon gave a pertinent analysis of the painter's

THE STONE BREAKERS AT LE RAINCY. C. 1882. Oil on canvas, 14 1/4 × 17 3/4″. *Private collection*

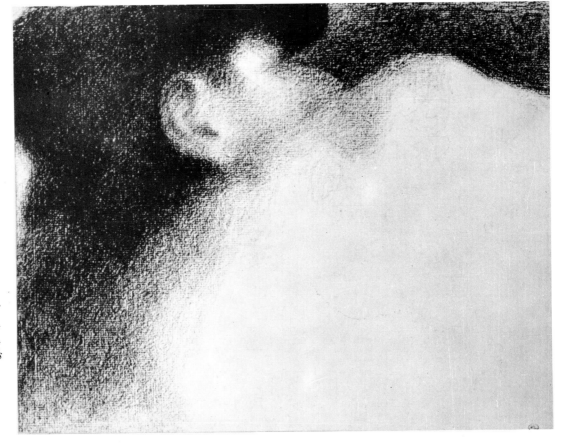

Seurat's theories concerning color and line, set forth in a document dictated to Jules Christophe

RECLINING MAN (study for *Bathing at Asnières*). 1883-84. Conté crayon, 9 1/2 × 12 1/4". *Musée d'Orsay, Paris*

technical achievement. Seurat cared so little about the subject that he used to tell his friends, 'I could just as well have painted a *Battle between the Horatii and the Curiatii*, in a different harmony.' He had chosen a Naturalistic subject just to tease the Impressionists, all of whose paintings he set out to redo in his own way."

NEXT TO HIS FELLOW STUDENTS, his closest friends made up the small group who founded the Société des Artistes Indépendants in 1884, to which Seurat was always to remain faithful. "No jury and no prizes" was the proud motto adopted by the society:

We Independents have one rule
With a jury we'll not fool.
It makes more sense, it seems to us,
To do without that stupid fuss.

The Salon des Indépendants was a haven for artists who had been rejected by the Salon d'Automne. They were in rebellion against the false teachings of the École des Beaux-Arts and the spoiled taste of the bourgeoisie. Day after day, these "outsiders" would pursue their researches in studios furnished neither with leopard skins nor other trophies, often stripped to the bare functional necessities—the tools of the trade.

Among the artists who now began to group themselves as followers of Seurat's scientific method, these Neo-Impressionists rejected the name *Pointillistes* ("dot makers," or even "spatterers") and cared even less for *Confettistes* ("confetti makers"), a term which could be applied with some justice to Italians such as Segantini who painted in dots but disregarded the division of tones. This was why they preferred the title of Divisionists. Seurat himself favored the designation "Chromo-Luminarist."

The painters who exhibited at the Salon des Indépendants were in the habit of meeting at the Café Marengo near The Louvre. Among them, the

BANKS OF THE SEINE AT SURESNES (study for *Bathing at Asnières*). c. 1883. Oil on panel, 6 3/8 × 9 7/8″. *The Cleveland Museum of Art. Bequest of Leonard C. Hanna, Jr.*

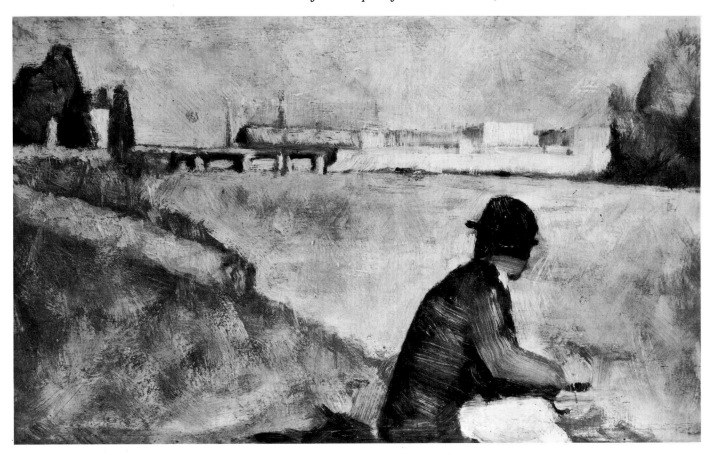

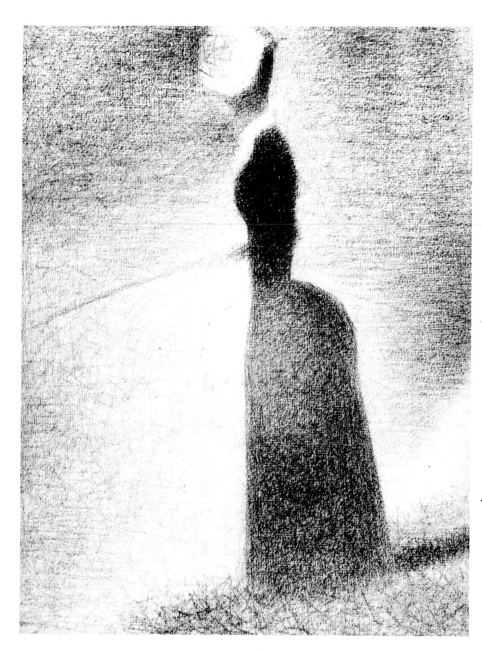

LADY FISHING. 1884-85:
Conté crayon, 12 1/8 × 9 3/8".
*The Metropolitan Museum of Art,
New York. Purchase, 1951 (Joseph
Pulitzer Bequest),
from the Museum of Modern Art,
Lillie P. Bliss Collection*

group of which Seurat was the leader included Paul Signac, Charles Angrand, Henri-Edmond Cross, and Albert Dubois-Pillet. Degas made a famous pun on the name of the last, which, if spelled a little differently *("du bois pilé")* denotes "sawdust." He said: "Sawdust makes the best Pointillism." This circle was eventually joined by Camille Pissarro and his son Lucien, Hippolyte Petitjean, Louis Hayet, the Belgian Théo van Rysselberghe, and Lucie Cousturier.

Among the painters who worked and exhibited with Seurat, and who like him practiced the fragmentation of tones (Albert Wolff, art critic for *Le Figaro*, wrote of them as "Communards who deserve to be shot"), we must first mention Signac, who was barely four years younger than Seurat and who remained a faithful friend and, in a sense, an imitator. He lived in a house adjoining Seurat's (at 130, Boulevard de Clichy; Seurat lived at 128 *bis*), and always proved a loyal companion to his possessive and touchy friend. An admirable pencil drawing by Seurat shows him in profile, brandishing his Malacca walking stick, top hat cocked rakishly. (Nearly all of Seurat's friends were fond of dressing like him. True, the silk stovepipe hat was fashionable at the time, but all of them seemed to have obeyed some mimetic law, for they dressed, shaved, and even trimmed their beards in exactly the same way.)

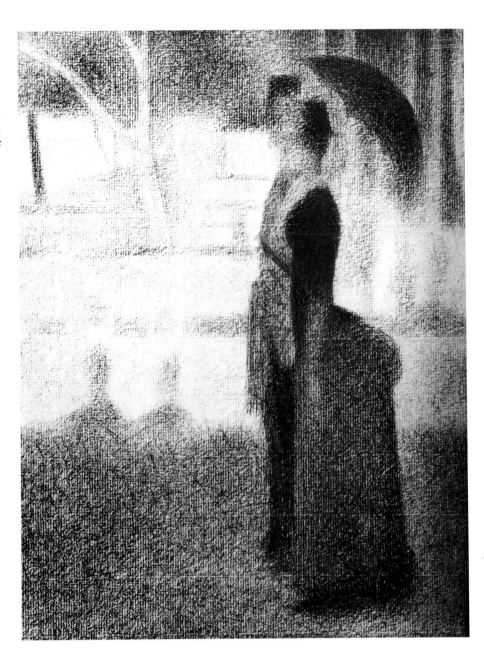

THE COUPLE (study for *La Grande Jatte*). 1884–85. Conté crayon, 11 1/2 × 9". *Private collection, Paris*

Maximilien Luce, who like Signac was a revolutionary socialist, painted workers in the smoke and grime of factories. Seurat had paved the way in this field with his early drawing *The Scaffolding* (c. 1883). In Montmartre (his studio was in the Rue Cortot) Luce was a figure often to be seen strolling about the streets, wearing spectacles and a soft felt hat.

Charles Angrand, a few years older than Seurat, lived at 45, Boulevard des Batignolles. With Signac, he seems to have been among those closest to Seurat, and his statements about the latter are especially valuable. An assistant teacher of mathematics at the Collège Chaptal, he supplemented his income by tutoring and devoted his leisure time to painting. He

was particularly taken to task for his "globule method" and his "ghostly specks." He appears in Seurat's *The Circus*, where he is to be seen seated just behind the railing by himself, bearded and mustached, wearing a high silk hat. (After Seurat's death, Angrand ended his days in an obscure town along the chalk cliffs of Normandy, where he spent his time making drawings on days when the spray was not too high.)

During Seurat's lifetime several vigorously articulate writers came to the defense of his art and of his technique. The first of these was Félix Fénéon, who praised *La Grande Jatte* in *La Vogue* of 1886 and gave a lucid account of its optics and technique.

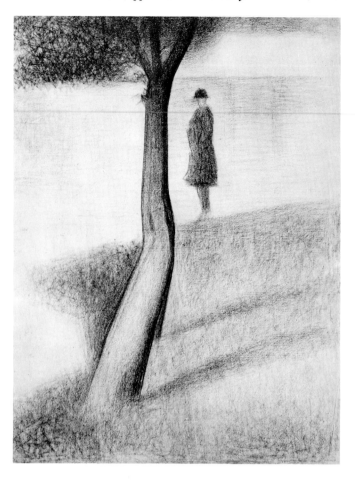

TREE AND MAN (study for *La Grande Jatte*).
c. 1884. Conté crayon, 24 × 18 1/8".
Städtisches Museum, Wuppertal, West Germany

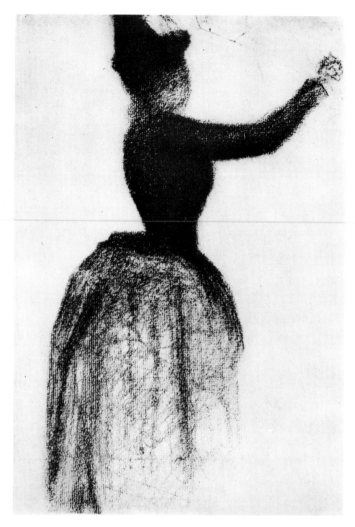

WOMAN WITH RAISED ARMS (study for *La Grande Jatte*).
1884–85. Conté crayon, 11 3/8 × 7 7/8".
Private collection, New York

Fénéon was reputedly possessed of a much-talked-about "legendary lewdness." He was also said to be "solemn and decorative," and brought to mind, Thadée Natanson tells us, the popular caricature of Uncle Sam wearing what looked like a false beard. "You brought me out of obscurity," Seurat used to tell this member of the last generation of really "arty" writers. Edmond de Goncourt tells us that Henri de Régnier described Fénéon to him as "a native of Italy who looks like an American, an intelligent man trying hard to make an impression, bursting out with axiomatic pronouncements, making a show of inner concentration, complete with little mannerisms intended to mystify—but for all that a good-hearted man, kind, sensitive, and apparently wholeheartedly devoted to eccentrics, to all who are poor or in trouble."

In 1886 Seurat also made the acquaintance of Jean Moréas, whom Fénéon described: "A rose in his lapel; blue-black hair spilling down over his brow; smoking a cigar; the black bars of his mustache with twisted ends pasted against his dull, even complexion; his right eye masked by a monocle." Moréas, the pope of Symbolism, had published *Le Thé chez Miranda*, a kind of prose elegy written in the Decadent style in collaboration with Paul Adam. The latter was just getting started on his lengthy series of long-winded novels. In 1887, at a time when it seemed to the critic Vanor that the official Salon had been taken over by "color orchestras that kick up one hell of a racket," Paul Adam went to see the Indépendants and, in the section where the Neo-Impressionists hung, it seemed to him that the walls "were riddled with light." After observing in *La*

Revue rose that the public at the opening seemed less horrified than it had been the year before, and after quoting Fénéon's comments on Seurat's technique, Adam wrote: "The work will be perceived with that special charm we feel when listening to a symphony. At the same time that we take in the full synthesis of the musical sounds, the value of every single orchestral element can be grasped as a unique and vibrant force." Going on to compare Seurat with the other Divisionists, he had no trouble casting him in the leader's role on the basis of the *Standing Model* (a preliminary study for *The Models*), the Honfleur pictures, and *The Bridge at Courbevoie*, all of which were exhibited that year.

A short man under his gigantic felt hat, looking like a faun with his slanting eyes and drooping nose, Gustave Kahn, the creator of *vers libre*, was in the thick of the advanced writing of the day. He occupied an apartment in the Rue de La Trémoille decorated with Japanese prints and pictures by Gustave Moreau, Cross, Luce, Signac, and Seurat. He called on Seurat when he was working on *The Models* in his studio in the Boulevard de Clichy, six floors up and under the roof: the same "white-walled anchorite's cell that we see in the composition, with its little stove and low, narrow bed across from some retouched old canvases standing next to a Guillaumin, some pencil drawings by Forain, and a poster by Chéret."

Finally, among Seurat's other writer friends, we must include Paul Alexis, "with his close-cropped hair, pince-nez over his nearsighted eyes, and bulging belly." He was a contributor to *Les Soirées de Médan*, the swan song of Naturalism. Seurat used his own portrait drawing of Alexis, done with conté crayon, for the figure of the ticket-taker in *The Side Show*. And then there was Maurice Beaubourg, author of the novel *La Saison au Bois de Boulogne*, who according to Coquiot was Seurat's favorite writer. When he came back from one of his expeditions to La Grande Jatte—when the urchins who went swimming there had not torn his canvas or broken his drawing board by throwing stones—the painter would walk with Alexis to Asnières to board the train. Seurat, "tall, rather dark-complexioned, tanned

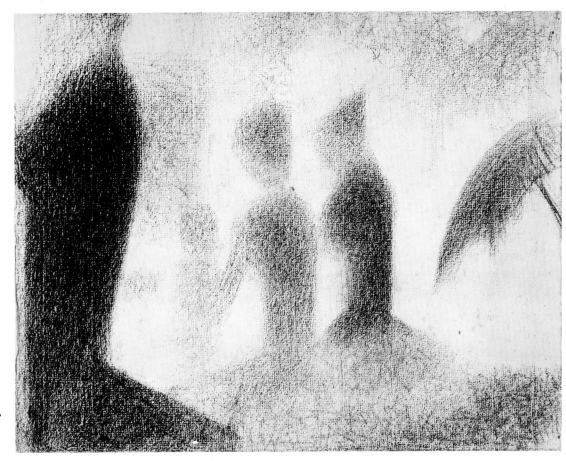

THREE WOMEN (study for *La Grande Jatte*). 1884-85. Conté crayon, 9 1/4 × 12". *Smith College Museum of Art, Northhampton, Mass.*

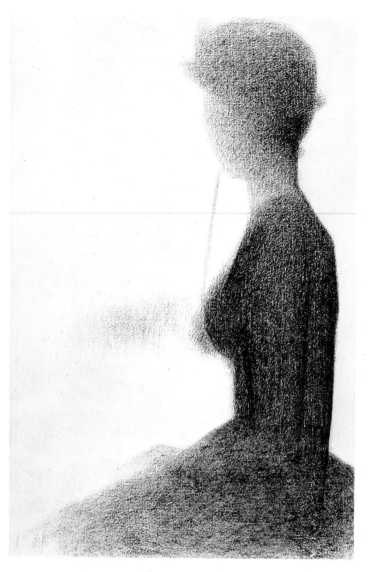

SEATED WOMAN (study for *La Grande Jatte*).
1884–85. Conté crayon, 18 7/8 × 12 3/8".
The Museum of Modern Art, New York.
Abby Aldrich Rockefeller Bequest

by the sun, his hair clipped very short," was "so thoroughly convinced of science's necessary and sufficient reason that I was nonplussed," Beaubourg says. Robert Caze was another writer acquaintance, who liked to make fun of "would-be socialists," a number of whom gathered around Seurat during this time. There was also Victor Joze, the not very talented author of *La Ménagerie sociale*, a series of second-rate novels in the vein of Zola's Rougon-Macquart series, for one of which, *L'Homme à femmes*, Seurat drew the cover (Lautrec and Bonnard drew covers for two others). And lastly there was Jules

Christophe, of whom little is known, a student of Balzac who dreamed of the emancipation of the masses.

One can imagine Seurat among these men, none of whom was really a close friend. With them the recluse no doubt spoke willingly of his art and of his technique, and was ready enough to demonstrate and comment on both. But he never confided in them, never opened his heart. We have no record that he ever said anything relating to his private life, nor to his opinions on politics or religion.

IN THE BRIGHT SUNSHINE at the edge of the water where his swimmers take their ease; on the grass, under the trees, where the Sunday strollers are crisscrossed by alternating bands of light and shadow; even in the studio where the models pose nude—all Seurat's works give off the sultry heat of midsummer. Sparkling, vividly alive, drenched in sunshine, everything in his pictures vibrates in a kind of perpetual chirping of crickets, a swirling of specks of light, and a swarming of bees.

Already in the earliest oils—men and women gleaning in the fields, men breaking stones along country roads, using picks and shovels, working in their gardens, swinging scythes in wheat fields— pictorial descendants of Courbet, Millet, and Van Gogh all inhabit a perpetual summer. And even later, when Seurat did not paint a picture until every detail of the composition had been worked out, his pictures still show us summer. It was summer even when Gustave Kahn came upon him in the Boulevard de Clichy studio, completing a big canvas "with zeal so strong and in a heat so oppressive that he lost pounds before it was finished." And it was summer when, every year from 1885 to 1889, during the dog days, he would go to Grandcamp, Honfleur, Port-en-Bessin, or Gravelines "to freshen his eyes after long days in the studio," as William I. Homer puts it, "in the summery isolation of clean nautical surroundings." There he would paint an unrippled ocean, for, as Angrand noted, "he was the first to render the feeling the sea inspires on calm days."

Signac, who introduced him to Port-en-Bessin, describes him at work. "With the motif in front of him, before making a single mark on his little panel, Georges Seurat looks, compares, notes the contrasts,

THE SCAFFOLDING. C. 1883.
Conté crayon, 12 1/2 × 9 1/8".
Private collection, Paris

discerns reflections, fiddles around a long time on the lid of the box he uses as his palette, struggling with the pigments as he had with the scene. And then, once he has laid out his little blobs of color in the exact order of the spectrum, he begins to pick out the ingredients with which best to express the mystery he has laid bare. Bit by bit, dab by dab, with frequent reference to the scene, the panel is filled up. And the masterpiece is created.''

The sun and water whose iridescent, boundless fluidity he renders—Seurat is their poet. Few have succeeded so well in making water give off such vibrancy. Sisley caught the reflections along the banks of the Loing, and Claude Monet in his shimmering waters where water lilies float also revealed the limpidity of time flowing into space. Both, however,

lack the synthesizing power that, in the steaming blue warmth of *Bathing at Asnières*, captures the whole lifespan of a summer, such as we had surely not been given since Bruegel the Elder. The Impressionists break up in tiny fragments the vision of a single moment, whereas Seurat gives it in its entirety. Bonnard alone, in those windows opening onto the lush foliage of July, achieved as strong an evocation. The sluggishly flowing Seine, the roofs of the houses at Argenteuil, the lady walking by with her parasol, everything in Seurat brings to mind summertime, vacation time, which to him meant the time he could work outdoors. There is not much spring, a few autumns, and one or two winters in small formats. His major works abound in July and August daylight, in pure skies and eternal warmth.

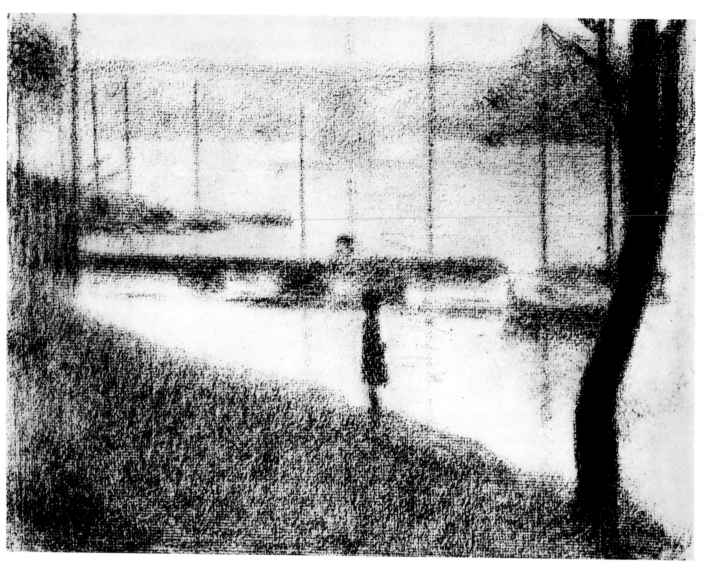

AFTER MANET's *Argenteuil*, Courbet's *Young Girls on the Banks of the Seine*, and Renoir's *La Grenouillère*, we have to recognize Seurat as the poet of the river. He is still painting it, this leisurely bearer of time and distance, when he captures it as it flows over sand and empties into the sea. Carrier of dreams at once precise and nebulous, fixed and relaxed, immobile and elastic, he depicts the river in broad daylight, at its mouth or along the sunshiny banks of La Grande Jatte. Was it not of this last, unique canvas that Proust was thinking when he wrote of the painting by Elstir, composite of many painters in the novelist's imagination:

There was something enchanting about this waterside carnival. The river, the women's dresses, the sails of the boats, the innumerable reflex-ions of one thing and another came crowding into this little square panel of beauty which Elstir had cut out of a marvellous afternoon. . . . This eye [Elstir's] had had the skill to arrest for all time the motion of the hours at this luminous instant, when the lady had felt hot and had stopped dancing, when the tree was fringed with a belt of shadow, when the sails seemed to be slipping over a golden glaze. But just because the depicted moment pressed on one with so much force, this so permanent canvas gave one the most fleeting impression, one felt that the lady would presently move out of it, the boats drift away, the night draw on, that pleasure comes to an end, that life passes and that the moments illuminated by the convergence, at once, of so many lights do not recur.

In the big canvas of *La Grande Jatte*, an eternally arrested moment in time (though nothing in it stands still), the concentration of light at the center holds the viewer's eye and makes him see the things in the picture in the order of importance the painter gave them. Down to the most faraway details, the picture is organized according to extremely delicate contrasts and analogies, which are not to be grasped save on repeated viewings. There is not the slightest oversight! The heat is present even in the coolest purplish-blue shade, the deep, ripe shade of mid-summer.

SEURAT IS THE ARCHITECT-PAINTER of verticality. His entire life's work seems to have been governed by the plumbline. He owed this to Humbert de Superville, according to whom the state of a body placed perpendicular to the horizon expresses the posture of man standing erect, turned toward the sky in the position of command. To justify his ethical implication, this author recalls that the ancient Romans never instructed their children in anything important while they were sitting down, because they wanted their young to be "upright." Gérard Bauër was not merely joking when he remarked that the figures in Seurat's pictures look as though somebody had just told them: "Stand up straight!"

Some painters put primary stress upon levels, upon horizontality. To Seurat, however, verticality comes before all else. With him the telegraph pole and the scaffolding holding up a building under construction enter the domain of painting with every bit as much authority as the column in ancient architecture. Whatever stands perpendicular to the plane of the horizon or to the surface of quiet waters catches his eye and intrigues him. The up-and-down line suggests to some a falling body, but it takes on an ascending character for Seurat. The verticals in his pictures constitute an order in themselves, a catalyst of the compositional forces; it is the stalk aspiring to spiritual fruition, the line that enhances all the others by defining their degree of inclination or curvature.

STUDY FOR "THE BRIDGE AT COURBEVOIE." 1886. Oil on panel, 5 5/8 × 9 1/4". *Private collection, Paris*

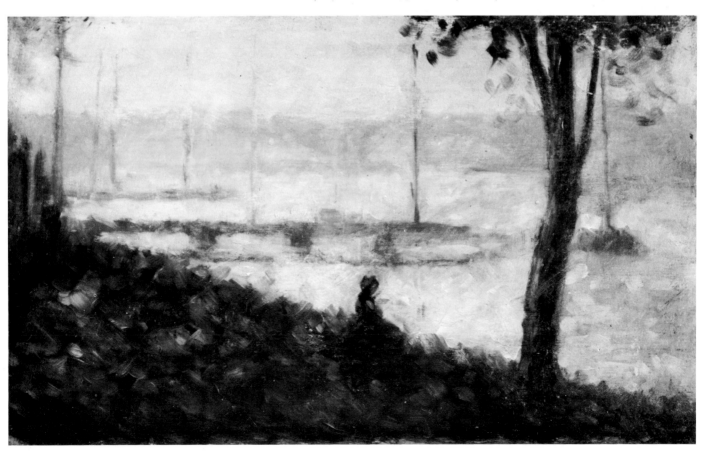

Maximilien Luce. GUSTAVE KAHN. Lithograph.
Courtesy Bibliothèque Nationale, Paris

Seurat's verticals are at once pledges of his uprightness, the columns of a temple, and surveyor's markings that tell us how his creations are to be read.

From the start, the painter was haunted by ascending lines—the roof line of a house in the suburbs, a row of stakes in the ground, factory chimneys, a single lamppost. Out of this preoccupation came the skillful juxtaposition of tree trunks in the landscape of *La Grande Jatte*—also the ships' masts, the lighthouses, the pilings of the docks in the seacoast pictures. Everything in Seurat's pictures, including the standing figure in *The Models* which sets the key for the big composition—everything is an application of the vertical and a hymn in its praise. (He could not resist making an oil sketch of the Eiffel Tower almost as soon as it was built.)

But it is in *The Bridge at Courbevoie* that the hymn of praise reaches its fortissimo. The masts of various heights, together with the factory chimney smoking in the middle of the landscape, produce a strange symphony with long and short verticals as its leitmotiv. Like so many musical whole notes and quarter notes, they stretch right across the canvas, as though to fill space with a metrical beat.

In *The Side Show* the use of the vertical is carried to the saturation point. Here everything is standing erect: the dark figure of the trombone player in the center, the other musicians in their derby hats, the tree at the left, the boards of the carnival shed and, against it, the upright figure of the animal tamer in profile.

After this work, sensing that he had taken verticality about as far as it could go, and that thereafter he must employ it more sparingly (though by no means nullifying it), Seurat moved on to the diagonals of *Le Chahut* and the swirling elliptical lines of *The Circus*.

IN SEURAT'S WORK there is something like a chemical

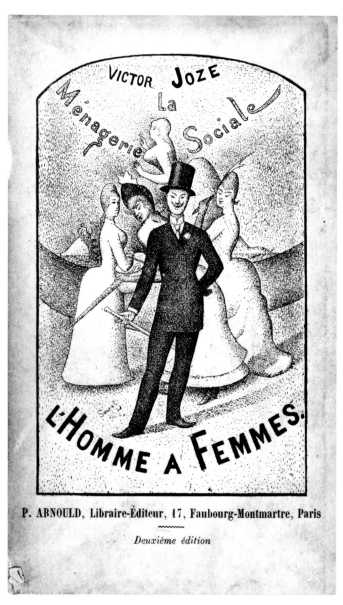

Cover of the novel *L'Homme à femmes* by Victor Joze,
with a lithograph after a drawing by Seurat

THE SEINE AT COURBEVOIE. 1884–85. Oil on canvas, 31 7/8 × 25 5/8″. *Private collection, Paris*

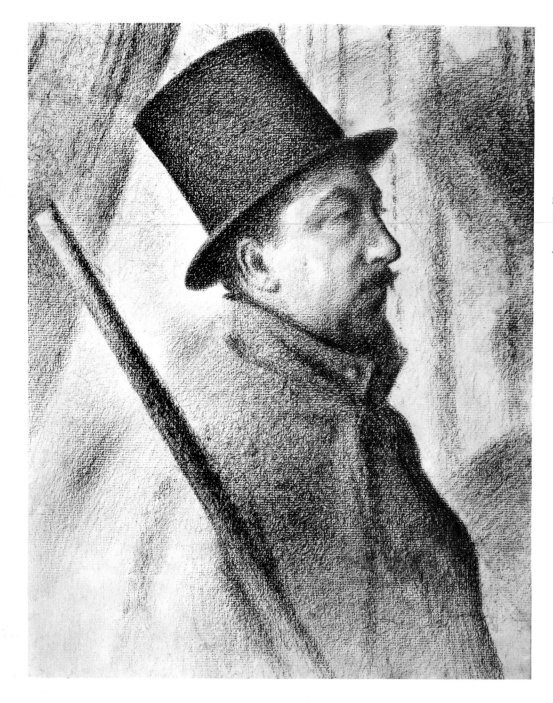

PORTRAIT OF PAUL SIGNAC.
1889–90. Conté crayon,
13 1/2 × 11″.
Private collection, Paris

distillation of the atmosphere. The shimmering veil that covers everything in his work brings to mind Rimbaud's "golden spark of Nature's light" or the phosphorescent glow of the starry firmament. Even Seurat's shadows give off light.

As he saw it, values come before lines. "It never occurred to him," says Cross, "to start a canvas by drawing a line on it." This is because Seurat does not describe: form in his work comes into being as something mysterious, at once dim and monumental. He was the first of the painters of his day to eliminate contours. Even in his early works, linear drawings are extremely rare. In almost every case boundary lines give way, in the light areas to broad irradiating surfaces, and in the shaded areas to silhouettes.

In Seurat we find the most straightforward attempt to do away with line. In his painting, dots serve as substitute, grazing the edges of the forms at every point so that they never cut up the canvas. "Contour escapes me," Cézanne was already saying. But the recluse of Aix-en-Provence had his own way of bringing out form by means of thick underlining

which, dark or light, is part of the ground and serves to set off the remainder. Seurat goes much further: he almost does away with contours entirely. He paints and draws alike in silhouetted planes, gradating the values from one area to the next. Nothing whatever is circumscribed! All that separates his planes is the juxtaposition of tones or values.

Seurat reveals himself most freely and fully in his drawings. Strokes of crayon cross the tiny ridges of the paper to produce myriad edgeless marks less deliberately arrived at than the dots in his oils, but just as expressive. In his landscape drawings the artist sometimes brings out the lugubrious aspect of a factory as a compact black mass in the moonlight. Or, again, he evokes Paris nights with a single lamppost or one carriage, or a square without an obelisk but instantly recognizable as the Place de la Concorde. In his renderings of human figures Seurat is more realistic. He shows men digging or a man standing as stiff as a ramrod holding a fishing pole. He treats his male figures as masses, bodies constructed in continuous volumes like those of the Mesopotamian sculptors. His renderings of women are much more differentiated, as when he evokes single figures gliding silently through twilit spaces. Their furtive, ghostly figures, caped and hooded, or in profile blurred as though by a veil, suggest the sparkling reality of some unearthly black diamond.

THE FIRST EXPOSURE to the Divisionist technique made an unfortunate impression upon many viewers. The calculated manner in which the colored pigment is conveyed to the viewer's eye, the way free treatment is reduced to all that confetti—for that was how Seurat's painting was seen—seemed a sort of straitjacketing of art, all the less excusable for being deliberate. As for the figures in his paintings, meticulously worked out as we see them in the final version of *La Grande Jatte*, they seemed to some about as lifelike as porcelain shepherds and nymphs.

Gradually, however, better understanding of why Seurat embarked on his laborious studies was gained, and at the same time his rigorously ordered art, his deeply moving orchestration of tones and colors, and his tireless search for a living geometrization of form began to be appreciated.

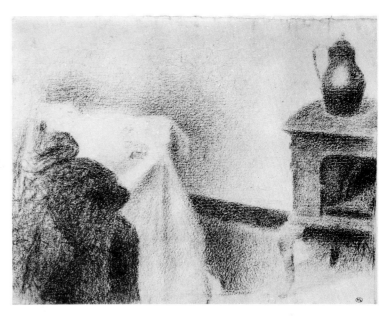

INTERIOR OF THE ARTIST'S STUDIO (study for *The Models*). c. 1887. Conté crayon, 9 1/4 × 12″. *Musée d'Orsay, Paris*

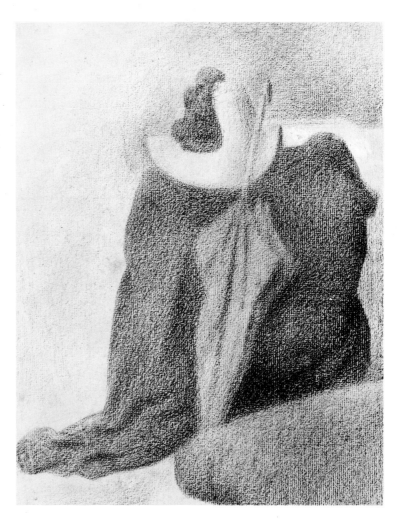

STILL LIFE (study for *The Models*). c. 1887. Conté crayon and gouache, 12 × 9 1/4″. *Collection Walter C. Baker, New York*

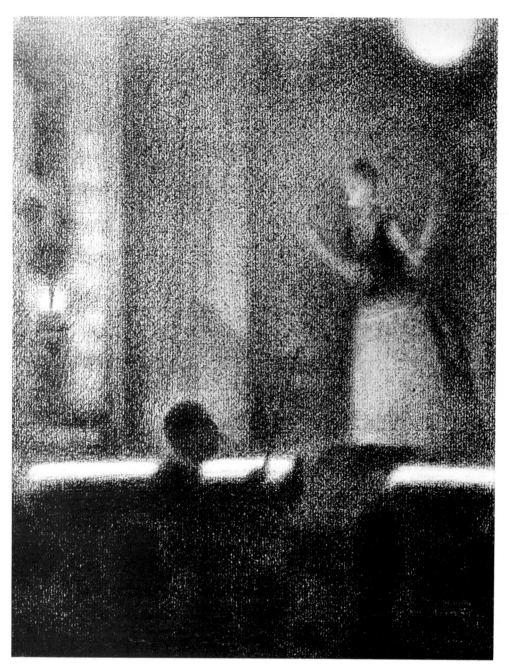

AT THE GAITÉ ROCHECHOUART
(CAFÉ CONCERT). 1887–88. Conté
crayon and gouache, 12 × 9 1/4″.
*Museum of Art, Rhode Island School of
Design, Providence. Gift of Mrs.
Murray S. Danforth*

Gustave Geffroy pointed out the danger in "the fragmenting of tones whereby the Neo-Impressionists were trying to render the sensation of lighted matter, radiance, reflection, and contrast all at once." The art critic of *Le Journal* went on to note that Balzac's frequently quoted but altogether admirable formula, of which no artist should ever lose sight, fully applied in this case: "To decompose is not to create." And he went on: "This does not outlaw the exercise of critical intelligence, of noble and necessary analysis. But one has to recompose."

In Seurat's case, however, the excessive preoccupa-

tion with method—and this is the miracle!—did not stifle the sensibility of the colorist and draftsman. Quite to the contrary, it heightened his sensibility, despite a lack of figurative imagination so great that he rehashed subjects Puvis de Chavannes had treated. (This at a time when it was said of Puvis: "He covers walls with the stones' own dreams.") Seurat even let himself be influenced by Jules Chéret, whose wriggling lemon-yellow Pierrettes and Columbines gave a certain lift to his posters.

The same public which, not long before, had attacked Corot for the wispiness of his trees, now rose

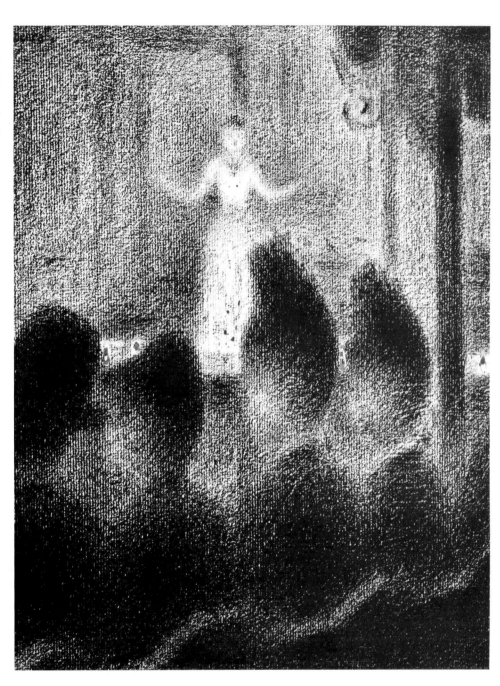

up in arms against the columnar trees in *La Grande Jatte.* "As usual," Gustave Geffroy pointed out, "the creators whose names have a gilt-edged value, and all who live off their continuing success, never fail to close ranks (whether openly or not) in joint resistance to the art of tomorrow." Seurat was not always praised, not even in avant-garde publications. In the *Décadent* for September 18, 1886, one Louis Pilate de Brin'Gaubast said in his review of the Salon des Indépendants that a canvas titled *Evening at Grandcamp* "suggests that he [Seurat] may be less unsuccessful as a dauber of landscapes than in

setting up wooden figures on the island of La Grande Jatte on a Sunday afternoon."

Fortunately, that same year Fénéon wrote in *L'Art moderne* for September 19 that the Neo-Impressionist method "requires exceptional subtlety of eye: all who cleverly conceal their visual incapacity by digital dexterity will run and hide, scared to death at his dangerous fidelity. This is a painting only *painters* can grasp: the studio jugglers will have to go back to card tricks and their cup-and-balls."

It has often been said that Seurat's oil sketches are better than his final versions, which, because of their

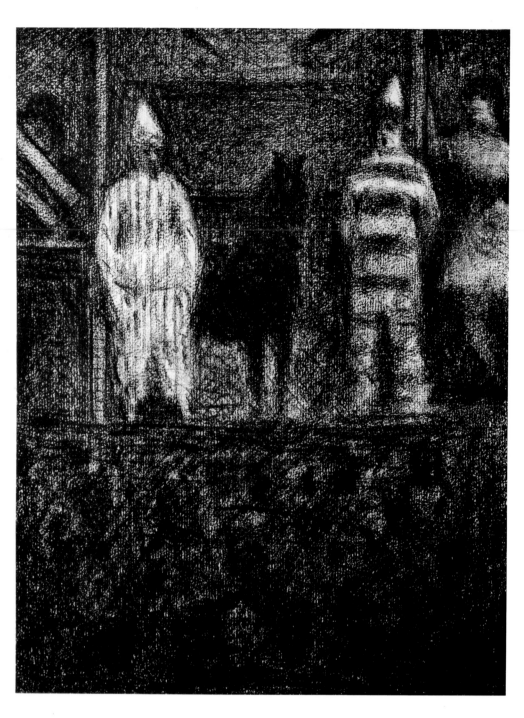

size, are much more meticulous, less vividly painted than the small preliminary panels. But is not the same true of any finished work?

Seurat's method was summed up best by Signac, next to Fénéon's somewhat stilted commentaries. "The Chromo-Luminarist," he says, "can secure the maximum of coloration, luminosity, and harmony (1) by an optical mixture of exceptionally pure pigments (all the colors of the spectrum and all their tones); (2) by separating the various elements (local color, lighting color, and their reactions); (3) by balancing these elements and their proportions (in accordance with the laws of contrast, gradation, and irradiation); and (4) by choosing a brush stroke in keeping with the size of the painting."

However, while the technique of the dotted brush stroke is fortunately carried by Seurat to a point where it is forgotten because the dots are so small as to be invisible at a distance, these dots produce still other effects beyond those of optics and color mixtures. As Meyer Schapiro has justly observed: "Seurat's dots may be seen as a kind of collage. They

create a hollow space within the frame, often a vast depth; but they compel us also to see the picture as a finely structured surface made of an infinite number of superposed units attached to the canvas."

The dot marked a step away from "reproduction." Since the brush stroke could not now be modified according to the material to be suggested, it became impossible to describe objects by corresponding changes in the brushwork. We know from Gustave Kahn that Seurat was an admirer of Vermeer, whose works exhibit an intricate and exquisite technique which, when studied under a magnifying glass, suggests, like Seurat's, the texture of roughly woven cloth.

For all that, the method represented a danger if taken too literally. Did not Seurat himself sense its weakness? "The more there are of us," he wrote Signac on August 26, 1888, "the less original we will be, and on the day when everybody is using the technique it will become worthless. Artists will start looking around for something new, as they are already doing." Does not this amount to acknowledging that, like all artists overly concerned with tech-

nique, he had perhaps ascribed excessive value to his discovery—to the point where he underestimated the most important thing of all, his own value as an artist? What matters today is not so much Seurat's theories of Chromo-Luminarism, but what he was able to do with them. What matters is that the painter was able to assert his talent as conclusively as he did, and this proves that the technique, when all has been said, served him well.

THE MONTMARTRE of the 1880s was a world unto itself. Seurat was young and, together with his friends, liked to mingle with the crowds in the evening, stopping to watch the outdoor shows put on by traveling carnival people under gaslights redolent with the acrid smell of acetylene. He would catch performances at the Concert Européen, at the Gaîté Rochechouart, the Divan Japonais, and the Cirque Fernando (later the Médrano), where he could study the movements of the clowns, the dancers, and the barkers. He could lose himself in the throngs of onlookers. Leaving his studio, Coquiot tells us, he had only "to walk a few steps and find himself in the

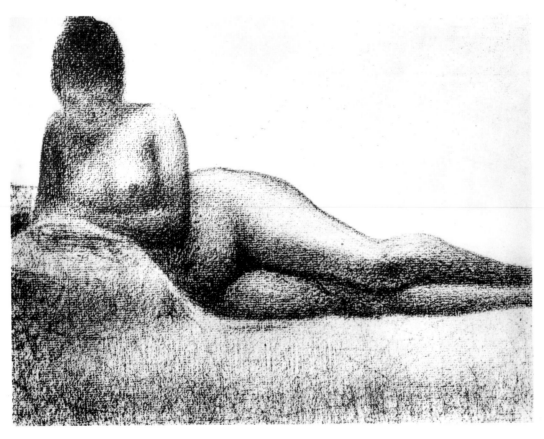

THE RECLINING NUDE.
c. 1888. Conté crayon,
9 1/2 × 12 5/8".
*Formerly Collection
Félix Fénéon, Paris*

39

dubious quarter to which flocked the dregs of the city, male riffraff and those females, young and not so young, who 'do' the garrison towns in the provinces on a fine evening, raucously belting out the couplets of *J'ai l'mirliton bouché* [My Little Reed Pipe's Plugged Up]." Occasionally, in the company of Victor Joze, he might stop in for a moment at La Cigale, where a fat woman with sad eyes would be singing *J'casse des noisettes en m'asseyant d'ssus* (No Nutcracker for Me—I Just Sits on 'Em).

The biographer of his life in Montmartre describes him as a "dandy in a tail coat and silk hat, strutting before a group of women wearing the *tronc de cône* [hats in the shape of truncated cones], bustles flaring." In front of the carnival booths wreathed by gaslights, was he as fond as his chronicler says "of sniffing the odor of french fries and garlic sausage"? What we do know is that he went again and again to the café-concert at the Ancien Monde where, after the vaudeville acts, they danced the can-can, "a hangover from the old Mabille and Valentino

Maximilien Luce. S E U R A T. 1890.
Charcoal and watercolor, 9 3/4 × 8 1/4".
Collection Frédéric Luce, Paris

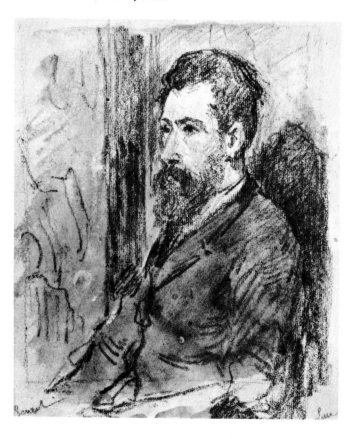

quadrille, the dancers being 'subjects' from the Élysée Montmartre who were known by such names as Ladybug, The Hussar, Artilleryman, and Blondinet." But to a mind like his, more and more preoccupied with perfect construction, all this would have resolved itself into verticals, curves, and cylinders.

Seurat lived and worked in the thick of all this. His studio was in the Pigalle quarter, not far from the Place de Clichy of which, Angrand tells us, he meant one day to compose an immense canvas as the urban counterpart to the upriver greenery of *La Grande Jatte*. Though he did not live to accomplish this, it was from his visits to the nightclubs and the carnival acrobats of Montmartre that he drew the subjects of his last compositions.

In *The Side Show*, which Fénéon thought "interesting as an application to the night scene of a method which had hitherto nearly always been applied to full daylight effects," Seurat's rigorism is carried further than ever. He breaks down the canvas into a number of verticals intersected by rigid horizontals, making the whole composition a set of premeditated rectangles up and down and across the picture. Having achieved so complete a geometrization of all the pictorial elements, he turned away from this in his next big painting, *Le Chahut*. Here the system is one of diagonals, with the lifted legs of the dancers echoing the slanting neck of the double bass in the foreground. And in the end he used swirling Baroque rhythms for *The Circus*.

Seurat, we are told, liked to go to the Chat Noir. And yet he did not at all possess the temperament of those who flocked in those days to such Montmartre cabarets as Salis', the Rat Mort, and the Moulin Rouge. Compared to Lautrec, Chéret, or even Renoir and Degas, we can hardly think of him as a fixture in the great days of the Butte. He never celebrated its windmills or the *midinettes* in their flowery hats. Jacques de Laprade speaks of a certain "bohemianism" in connection with *The Side Show*. But if there is any one thing this painting conveys, it is certainly not curiosity to know what is going on inside. Nor is there anything very titillating about *Le Chahut*. Writing of it with an unctuous sensuality entirely his own, Coquiot felt it evoked "the perversion of smells, the fleshy odor of woman, here

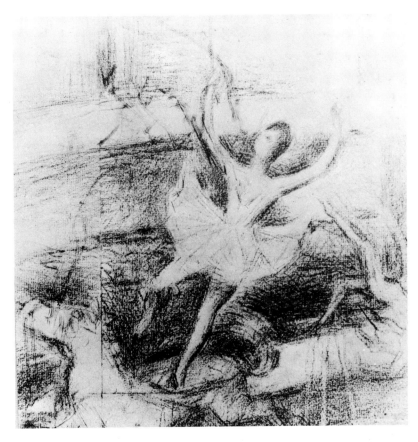

BAREBACK RIDER (study for *The Circus*). 1890.
Conté crayon, 11 7/8 × 11 7/8″.
Private collection, Paris

not driven away by make-up and tincture of benzoin."
But there is nothing of this sort anywhere in Seurat's
art. He was merely fond of the effects of artificial
light; he was, says Gustave Kahn, "haunted by night's
magnificence." His Paris scenes are always night or
evening, after the lamps have been lit. His Mont-
martre is not at all that of the visitor "out for a night
on the town." The ambiguous libertinism of La
Goulue's clowning, the spectacle of aging lechers—
these were not for him. Seurat was a precursor of
Cubism interested in making the tightest possible
compositions out of the scenes he found closest at
hand.

Similarly, there is not the slightest eroticism in his
figures of women. In his work they are passers-by,
not obsessive presences, not objects of passion or
desire. To him, woman was something like a chess
piece. Modest, almost asexual, she merely obeys her
master without trying to interpose between herself
and him the temptation of her sex.

In the *Young Woman Powdering Herself* Seurat
painted the portrait of the mistress he took in his last

years. Originally he had painted his own features
between the panels of the wall mirror, but later
changed it to the vase of flowers. Again, he hardly
makes his paramour, Madeleine Knoblock, appear
very exciting.

There is, however, one exception in his work. *The
Reclining Nude*, the conté crayon drawing which
belonged to his mistress and which may be a portrait
of her, suggests that Seurat for once let himself be
carried away by this lovely stretched-out body with
its luscious curves. The light on breasts and thighs is
a caressing light.

But apart from this one anomaly, Seurat's concep-
tion of his art was an ascetic one. A Pygmalion in
reverse, he was really trying to dispose of the living
model entirely, to transform her into his thing, his
object—an architectonic form.

HAD HE ANY PRESENTIMENT that his time had nearly
run out? Early in 1890 Seurat addressed himself
frantically to a composition that would take a year of
work and which he would not live to complete. This

HEAD OF A CLOWN (study for *The Circus*). 1891. Conté crayon, 6 1/8 × 12 3/8". (Inscription in the hand of Paul Signac.) *Private collection, Paris*

was *The Circus*. At the Cirque Médrano he made tiny sketches in the palm of his hand. The compositional scheme was one of ovals, trapezoids, and ellipses, somewhat on the model of Raphael's *Transfiguration*, the structure of which David Sutter had analyzed. Straight lines now gave way to the curve and the circle. The horse, the lady bareback rider, and the clowns are all in frenetic movement, galloping, jumping, performing acrobatics around the ring while the spectators sit immobilized in the tiers of seats. Did he, perhaps, doubt his own reflexes? Wanting the public and his fellow artists to see it, he exhibited the unfinished canvas at the Salon des Indépendants in 1891, never suspecting that the hand of which he was so proud would add no further touches to those swirling arabesques.

Arsène Alexandre, who was seeing him regularly at this time, describes his comings and goings, the way he climbed up the ladder and down again, how he worked long into the night (for he had long since achieved such mastery of color that even under artificial light he knew exactly how the colors would look in daylight). Angrand, who also watched him working at this time, could not keep from making a few objections to so many theoretical refinements. "For," he says, "from binary harmonies Seurat went on to ternary ones, and the lines had to follow the colors. Picking up a stool to demonstrate with, this rather shy, uncommunicative man suddenly became positively eloquent—with the eloquence of deep conviction."

On February 3, Seurat attended a banquet under Mallarmé's chairmanship in honor of Jean Moréas. The guests included many old friends and acquaintances, among others Fénéon, Gauguin, Signac, Odilon Redon, Henri de Régnier, and Octave Mirbeau.

A few weeks later he worked very hard at the Pavillon de Paris in the Champs-Élysées, hanging the works for the Salon des Indépendants that year. They included a retrospective showing of Dubois-Pillet, who had died the year before from smallpox. Of his own work he exhibited four Gravelines landscapes and *The Circus*. He had a minor disappointment at the opening. From the back room where he was sitting with Angrand, he saw Puvis de Chavannes coming in with his wife. "He'll notice the mistake I made in my horse," Seurat said to his companion. But Puvis went by without stopping.

An infection in his throat which had developed during the hanging of the pictures grew worse. It was diagnosed as infectious quinsy, and Seurat was confined to bed. After a short crisis marked by fever and delirium, he "choked to death" on March 29, 1891, at 6 A.M., at the age of thirty-one. Madeleine Knoblock was left without the legal rights of a wife, and their thirteen-month-old child caught the infection and is said to have died a short time later. (No documentation of the child's death has been found—neither at the *Mairie* of the Tenth Arrondissement—Boulevard Magenta—nor at the *Mairie* of the Eighteenth—Passage de l'Élysée des Beaux-Arts.) It has until now been thought that Seurat died

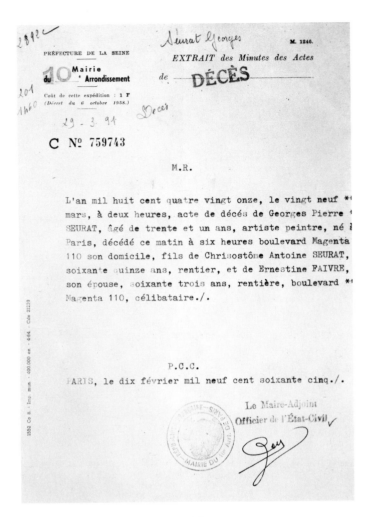

Extract from Seurat's death certificate

quayside, one bush against a simple background provided enough of a motif, and who knew how to give a nuance to any surface." When Seurat, the poet of Chromo-Luminarism, had gone, Divisionism lost all attraction. As early as April 1, Camille Pissarro was writing his son Lucien: "I attended Seurat's funeral yesterday. Signac was there; he is deeply shocked by this great misfortune. I think you are right: it's all over with Pointillism."

Preoccupied with space and distance as he was, Seurat opened our eyes to many new possibilities of optics and vision. His strength was to have been able to combine the eye and the heart, scientific analysis and poetry. One might say that the shimmering light he invented makes us see what is most

MAN AT A PARAPET (THE INVALID). C. 1881.
Conté crayon, 9 1/4 × 6".
Collection Jacques Rodrigues-Henriques, Paris

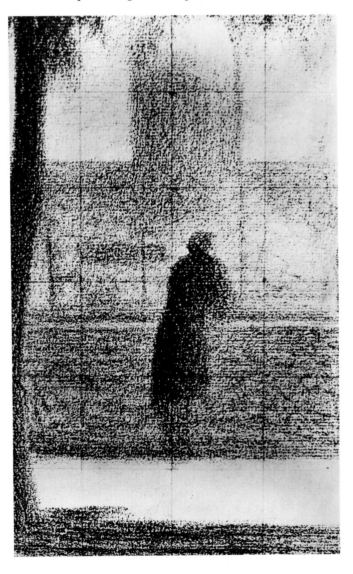

at his mother's house, at 100, Boulevard Magenta, but on the death certificate 110, Boulevard Magenta is listed. The Passage de l'Élysée des Beaux-Arts was thus reserved for his studio and private life. It was from there, the day after the painter's death, that Madeleine Knoblock (who said at the time that she was a seamstress) went at 10 A.M. to the *Mairie* of the Eighteenth Arrondissement, accompanied by a shoemaker who had his shop in the building and a wine dealer from the Rue des Abbesses. There, she made formal declaration, in the presence of the officer of the Civil Register and her own witnesses, that she was the mother of the child she had borne Seurat.

So died the man who in his lifetime had sold only a few paintings. His passing was mentioned nowhere in the press, which was busy that year publishing many articles on the death of Meissonier. It was a modest departure from the scene, the passing of this painter for whom, said Angrand, "one stone by a

enchanting in nature at those moments when she seems to us most sublime; he enhanced our vision with his selection of motifs, his color, and his superbly orchestrated gradations between black and white. Around the silently gliding figure of a woman walking her dog along the banks of the Seine under thick, small-leaved poplars, Seurat gives us, not just the fine drizzle of rain, but a magically shimmering, quivering, throbbing, vibrating, sparkling environment. He painted space according to scientific laws governing tones, hues, and brush strokes—yet inside his space we feel the passing of time. There is life going on for all his careful construction, owing especially to the three kinds of lighting which Seurat was the first to use so skillfully: broad daylight (*La Grande Jatte*), the subdued light of the studio (*The Models*), and artificial light (*The Side Show*; *Le Chahut*; *The Circus*).

One study dating from his youth, one of the earliest, *Man at a Parapet*, also known as *The Invalid*, seems to sum up the art of this painter in the way auras of light and shadow are projected. Reticent, profound, impenetrable, Seurat's mature style is already fully present in this small painting with its silhouetted tree, the way the light strikes the wall, the way the dreaming figure appears to be looking out toward the mirage of some tower or dome rising mistily above the water in the background. The atmosphere is conveyed in modulated planes, straight lines, and curves—all of perfect harmony. In order not to be inhibited by theory, such self-discipline as Seurat's demanded an unusually solid innate talent.

In the end, despite his limited output (a little over two hundred paintings and seven hundred drawings),

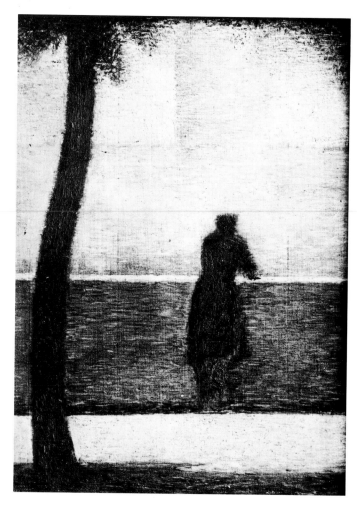

MAN AT A PARAPET (THE INVALID). C. 1881. Oil on panel, 9 1/4 × 6 1/4″. *Private collection, New York*

what he did leave behind seems especially gemlike—as happens in the case of those who die young. So much so that, on the endless fresco where every illustrious painter leaves his image, that of Georges Seurat will always possess the rare quality of being irreplaceable.

BIOGRAPHICAL OUTLINE

1859 DECEMBER 2: Birth of Georges-Pierre Seurat in Paris at 60, Rue de Bondy, in the Fifth Arrondissement. His father, Antoine-Chrisostôme, aged 44, a native of Champagne, is a property owner; his mother, Ernestine Faivre, aged 31, is a Parisian. Very soon after Seurat's birth, his parents move to 100, Boulevard Magenta. His father, an eccentric, spends most of his time at a house he owns at Le Raincy. Young Seurat lives with his mother, his brother Émile, and his sister Marie-Berthe (later Madame Léon Appert).

1871 During the Paris Commune the Seurat family takes refuge at Fontainebleau.

1875 Seurat, having discovered that he can draw, begins to attend classes under the sculptor Justin Lequien at a municipal school of drawing in the Rue des Petits-Hôtels, a few steps from his mother's house.

1876 Last year at the *lycée*. At the drawing school Seurat meets Edmond Aman-Jean and Ernest Laurent, and rents a studio with them in the Rue de l'Arbalète.

1877 Prepares for admission to the École des Beaux-Arts; makes many drawings from classical casts.

1878 FEBRUARY: Is admitted to the painting department of the École des Beaux-Arts.

MARCH 19: Admitted to the École proper, in the studio of Henri Lehmann, a pupil of Ingres and a painter of academic nudes. Seurat frequents the library, where he reads a great deal, and The Louvre, where he studies the old masters and makes copies. He is greatly impressed by the writings of David Sutter, a Swiss aesthetician, born in Geneva in 1811, who was steeped in mathematics and philosophy. His treatises on optical beauty and the decomposition of light call Seurat's attention to the Italian primitives.

1879 NOVEMBER: Goes to Brest for his year of military service as an enlisted man. Draws the sea, beaches, boats.

Photocopy of Seurat's birth certificate

45

1880 NOVEMBER: Returns to Paris, installs himself at 19, Rue de Chabrol, not far from where his mother lives.

1881–82 First experiments in his studio.

1883 Exhibits at the Salon for the first time—portrait drawings of his mother and of his friend Aman-Jean. Earliest oils, panels, and many drawings for *Bathing at Asnières*, which he completes.

1884 *Bathing at Asnières* is rejected by the Salon.

MAY: Helps found the Association des Artistes Indépendants.

JUNE: Exhibits *Bathing at Asnières* at the first Salon des Indépendants. Meets Paul Signac. Makes many preliminary studies for a big canvas, *A Sunday Afternoon on the Island of La Grande Jatte*.

DECEMBER: Exhibits *Bathing at Asnières* again at the Indépendants, as well as studies for *La Grande Jatte*.

1885 MARCH: Completes *La Grande Jatte*, on which he had worked intensively during the winter. Spends the summer on the Channel coast at Grandcamp.

OCTOBER: Back in Paris. Reworks *La Grande Jatte*. Is introduced by Signac to Camille Pissarro.

DECEMBER: With Pissarro, talks to Monet about organizing a new exhibition of the Impressionists.

1886 MARCH: Represented in first New York showing of works of Impressionists.

MAY 15–JUNE 15: Exhibits with the Impressionists at the eighth Impressionist exhibition, at the Maison Dorée, Rue Laffitte, with Signac and Pissarro. Fénéon speaks of him and praises his technique in *La Vogue*, an avant-garde magazine.
Spends summer at Honfleur.

AUGUST–SEPTEMBER: Is represented at the second Salon des Indépendants. Agrees to take part in the fourth Exposition des XX in Brussels the following February.

1887 Begins *The Models*.

FEBRUARY 2: Opening of the Exposition des XX,

for which Seurat goes to Brussels with Signac; exhibits seven paintings.

MARCH 26–MAY 3: Exhibits landscapes, drawings, and a study for *The Models* at the third Salon des Indépendants.

1888 Finishes *The Models*, which he exhibits at the fourth Salon des Indépendants in April, and *The Side Show*.
Spends part of the summer at Port-en-Bessin.

1889 Paints portrait of Signac. Lives at 39, Passage de l'Élysée des Beaux-Arts.

1890 FEBRUARY 16: Madeleine Knoblock, aged 22, Seurat's mistress, then officially registered as "no status," gives birth to a son. Seurat recognizes paternity and the child is entered on the Civil Register as Pierre-Georges Seurat.
Completes *Le Chahut*. Finishes *Young Woman Powdering Herself*, first known portrait of Madeleine Knoblock. Begins *The Circus*. Spends the summer at Le Petit-Fort Philippe, Rue de l'Esturgeon, Gravelines (Nord). Paints landscapes there.

1891 MARCH 20: As though moved by foreboding, Seurat shows *The Circus*, still unfinished, at the eighth Salon des Indépendants, which is to run until April 27.

MARCH 29: Death of Seurat at 6:00 A.M. at 110, Boulevard Magenta. He had caught a chill supervising the hanging of pictures at the exhibition and developed an infected throat.

MARCH 30: Madeleine Knoblock appears at the *Mairie* of her *arrondissement* to declare herself the mother of Pierre-Georges Seurat.

MARCH 31: Funeral of Seurat. He is buried at the Père-Lachaise cemetery, sixty-sixth division, first line, no. 7–67, in the family vault.

APRIL 23: In a letter to Fénéon, Madeleine Knoblock gives her address as 39, Passage de l'Élysée des Beaux-Arts. After the estate was divided, she inherited *Le Chahut*; the big canvas of *The Models*; *Seated Model, Back*; *Young Woman Powdering Herself* (her own portrait); two Gravelines landscapes; *Evening, Honfleur*; several panels; and some drawings.

COLORPLATES

Painted about 1879

HEAD OF A GIRL

Oil on canvas, 11 3/8 × 9 1/2". Unsigned

The Dumbarton Oaks Research Library and Collection, Washington, D. C.

Seurat's originality asserts itself in this very early work by the clear precision of his drawing and the way he sets the dark hair against the light ground.

This portrait falls between a copy of an Ingres and a work in the spirit of Puvis de Chavannes. At about the same time Seurat painted a woman bathing, in the manner of Cézanne, and a mythological scene (*Jupiter and Thetis*) in the manner of Henri Lehmann.

This head (the model may have been a cousin of the artist's) represents the curtain going up on Seurat's career. We are witnessing the birth of his art. An artist's first attempts often disclose the full range of his talent, whereas the period that follows is often one of groping.

The neck and hair in this one-quarter view show the earliest use of the neat brush strokes which will characterize the technique of *Bathing at Asnières*. Seurat here is already doing away with contour lines, though they had figured in his earliest drawings. The pose of the head recalls certain slightly turned-away faces in Italian painting. It carries splendid conviction.

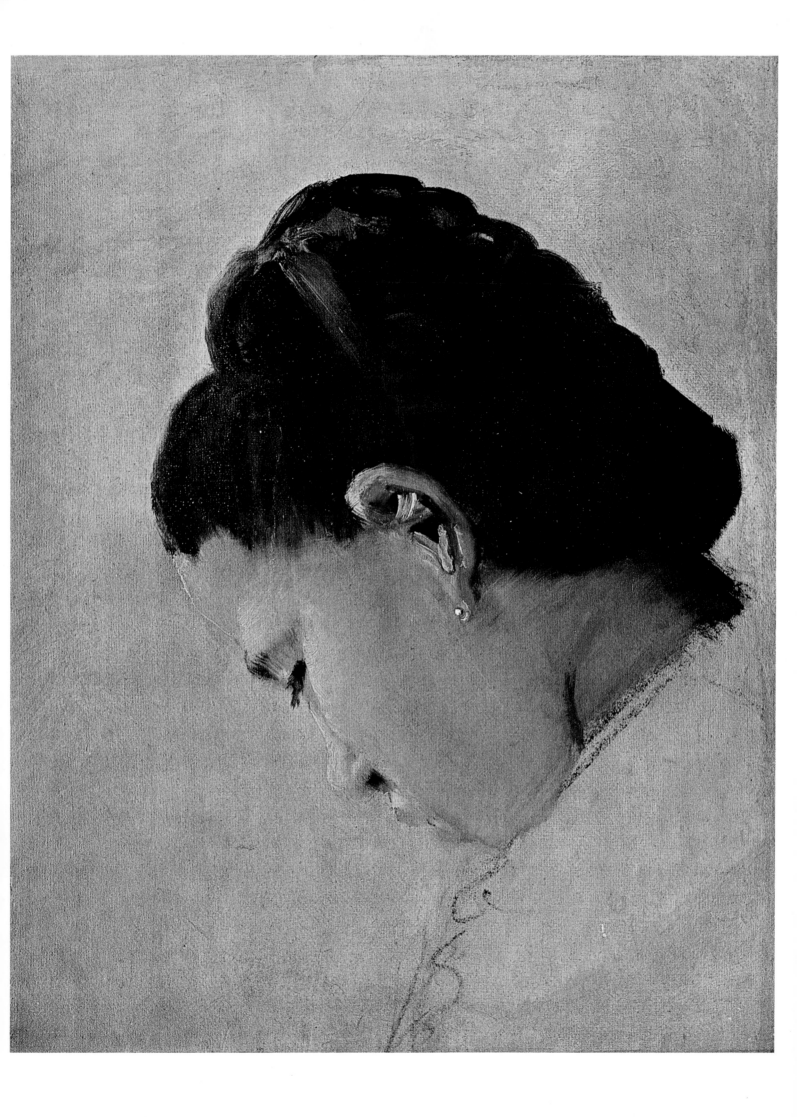

Painted about 1882

IN THE WOODS AT PONTAUBERT

Oil on canvas, 30 3/4 × 24 3/4″. Unsigned

Private collection, London

Here, the shimmering light of the later works is presaged. The atmosphere is rendered by dots that form a golden mist. This technique of a facile, almost Pre-Raphaelite symbolism was later employed by his friend Ernest Laurent with disastrous results, and eventually degenerated to Gaston Latouche's gilded banality. Seurat, however, makes but sparing use of it in this sentimental mood. The tree trunk at right imparts solidity to the melting landscape, and the other lines have been thoughtfully distributed.

Behind the elegiac appearance of this canvas we can discern certain qualities which Seurat will develop later. The stiffly vertical tree in the foreground will turn up again and again—in *La Grande Jatte*, in *The Seine at Courbevoie*, and in other works.

This painting, the only one of its kind by Seurat to stress the fragility and charm of undergrowth, was formerly owned by Émile Seurat and by Alexandre Natanson. It was exhibited *(hors catalogue)* at the Seurat exhibition sponsored by *La Revue Blanche* in 1900.

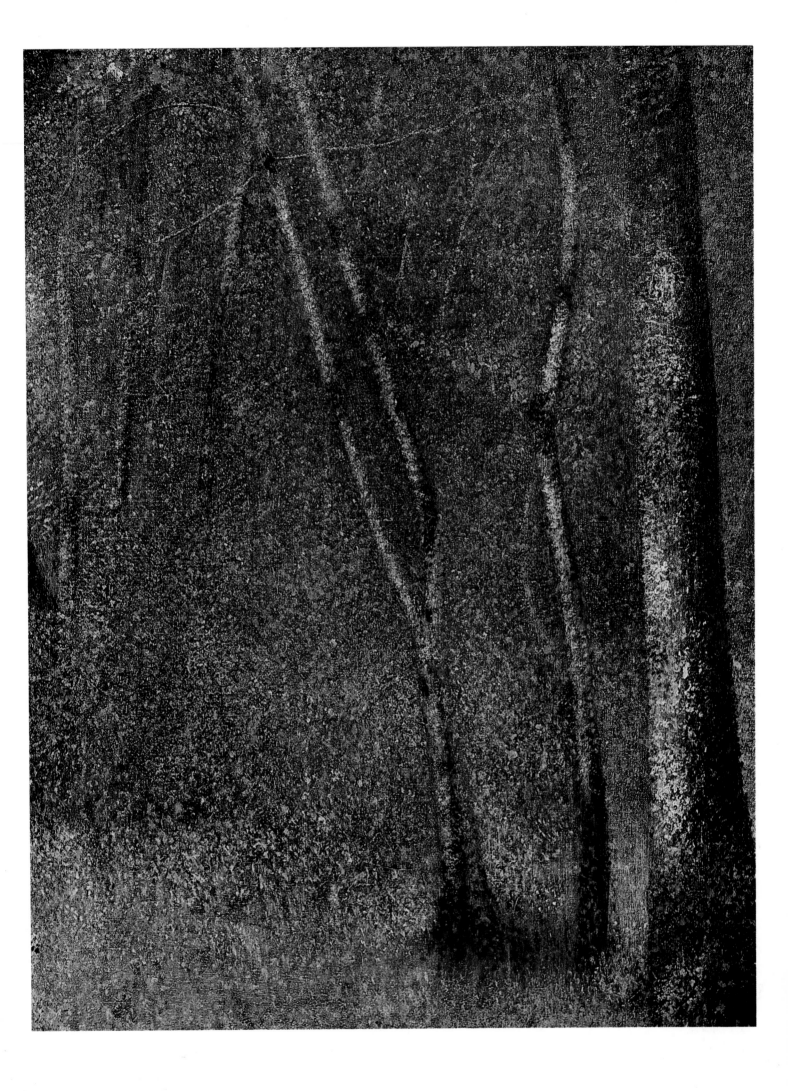

Painted about 1882

PEASANTS DRIVING STAKES

Oil on canvas, 5 3/4 × 10". Unsigned

Collection Mr. and Mrs. John L. Loeb, New York

This is one of many paintings in which Seurat makes marked use of verticals. They had an explicit meaning for him, suggested by Humbert de Superville, the writer on aesthetics. According to the latter, "in relation to the vertical and any line parallel to it, there are three possible directions of lines or planes: one horizontal, and two kinds of slanting lines, which can be endlessly modified." To him the different kinds of line denote order, stability, balance, permanence—or motion, inconstancy, change—or meditation, elevation of mind.

Here and there the panel shows wooded areas of scrublike growth. We see here the whole range of *tachisme*—slashes, comma-like strokes, dots, and slanting bars.

Between the tonal extremes of earth and sky, Seurat's composition is concentrated in a diagonal band which vanishes into distance at the left. Viewed up close, only light and dark spots may be perceived, but when seen from a distance the movements of the men take on a marvelously natural quality, and they are even individualized.

Though the motif might lead to mere sketchwork, Seurat had too pure a sense of his art not to be searching constantly for the right color and composition, one which would express his own personality. Surrounded by people who, like Maximilien Luce, flirted with socialism, in the fashion of the period, and the fire-eating Jules Guesde, Seurat also took an interest in the life of the working classes and the peasants. His figures of them, however, are timeless. These men at work move about a sun-drenched space, and the stakes they are driving stand up in the landscape like so many beacons of hope and faith.

This picture turned up in the posthumous inventory of Seurat's works.

(Bottom)

Painted about 1883

HORSE

Oil on canvas, 13 × 16 1/8". Unsigned

The Solomon R. Guggenheim Museum, New York

This, in the richness of its construction, is one of the most rigorous and satisfactory of Seurat's works. As early as 1883, Seurat began to draw away from the influence of Puvis de Chavannes and return to the study of Nicolas Poussin. He resolved to show nothing on the canvas that he had not first organized in his mind. The triangular composition of this small work, a marvel of silence and suspense, is admirable in every way. The picture has the viewer waiting for something to happen—and it is clear that something *is* about to happen. There is a sense of calm expectancy in this work which is perhaps unequaled in all painting.

No single element in this composition could be altered: the horse, the tree trunk, the hedgerow—everything is just where it should be. In some unknown way the artist manages to touch us deeply with a very simple subject.

The fact is that he made many preliminary studies for this small canvas. He proceeded systematically, first reproducing what he had been able to observe in nature and then gradually eliminating all unnecessary description until he had attained this superior order in which every detail counts, in which nothing is mere imitation. The form is so deeply etched that it becomes obsessive.

The tones of the field and the background, in juxtaposition with those of the horse, tell us clearly that here, for Seurat, color comes last. He makes it sing as agreeably and spontaneously as an Impressionist, but not until he has meticulously worked out the drawing and layout of his composition.

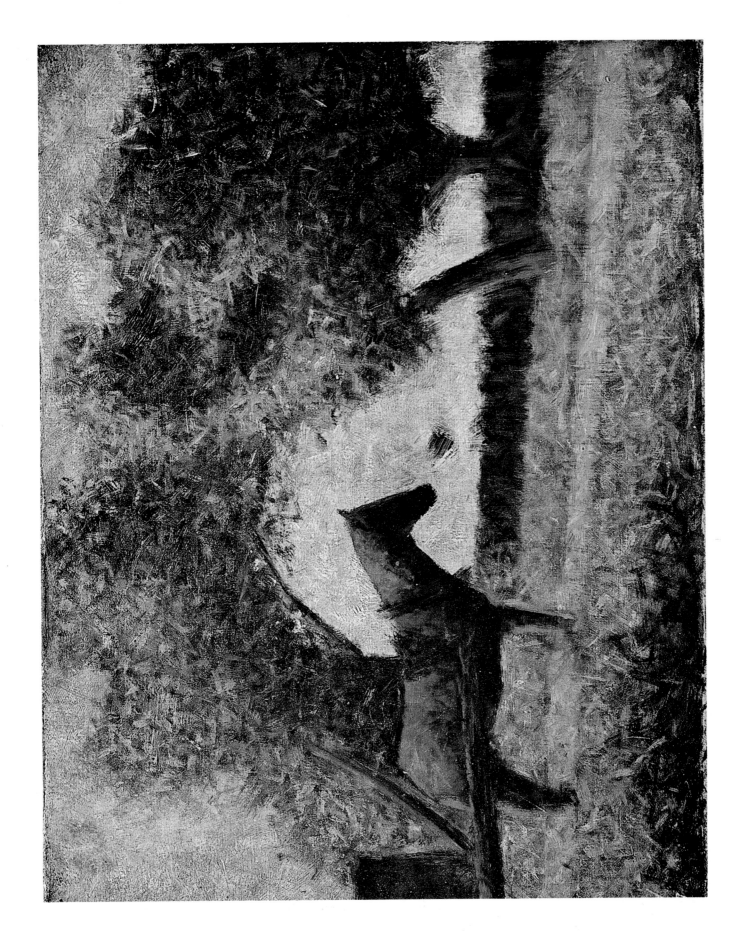

Painted about 1882–83

SEATED WOMAN

Oil on canvas, 15×18 1/4". Unsigned
The Solomon R. Guggenheim Museum, New York

Painted when Seurat was twenty-three, this youthful work shows how deeply influenced he was by Puvis de Chavannes, unquestionably one of the most successful French artists toward the close of the nineteenth century. Like Puvis, Seurat firmly sets down a single sculptural silhouette so that it stands out against a lighter background. Although Puvis' influence on Seurat extended even as late as some of his studies for *Bathing at Asnières*, it is sure that Seurat—who according to Fénéon was a "more modern Puvis"—was never guilty of "idealized" imagery. Puvis, painter of creditable but pallid decorative works, simplified his forms in a way very different from Seurat's. The latter worked rather in the Giotto-Poussin tradition. Puvis' error was to have destroyed the life of his forms by stylizing them. His excess of restraint led to pictorial poverty, whereas Seurat keeps his forms animated even as he strips them to their essentials.

Nonetheless, Seurat saw very well the value of what is Puvis de Chavannes' main contribution—what Henri Focillon called his "moral landscape." By no means will all his allegories be forgotten—paintings like *Hope* and *The Poor Fisherman* will survive. Yet, while appreciating Puvis, Seurat skillfully avoids falling into anything like academicism, and does not betray the slightest hint of Symbolism—he who lived in the midst of "Decadent" poets and writers.

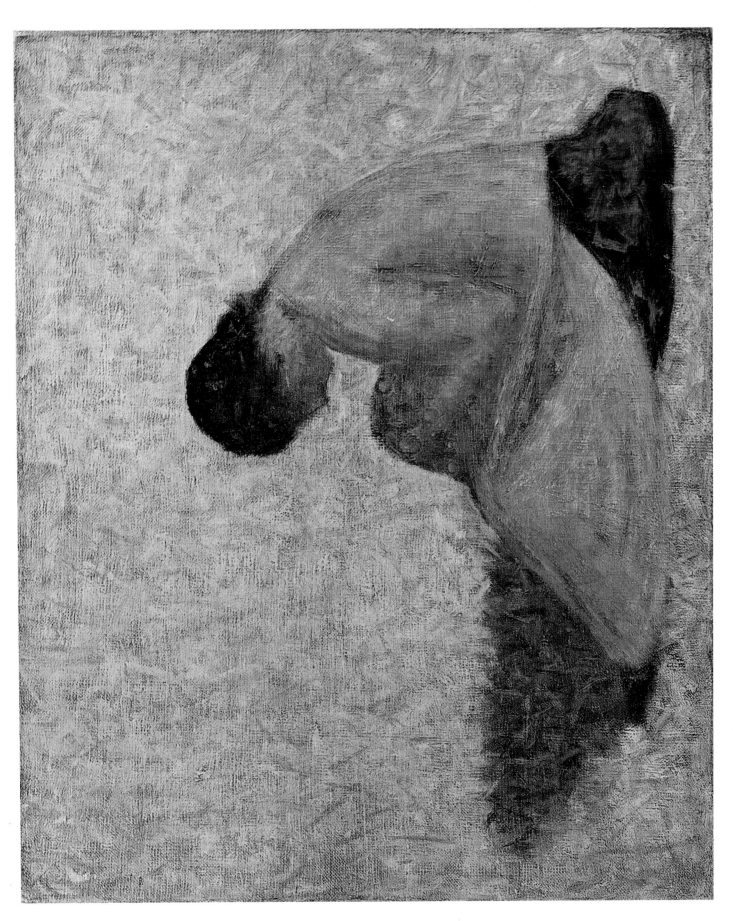

Painted about 1883

THE STONE BREAKERS

Oil on panel, 5 7/8 × 9 1/2″. Unsigned

Collection Mr. and Mrs. Paul Mellon, Upperville, Va.

Here, the figures of the laborers are overshadowed by the big dark areas of standing and upended carts silhouetted against the sky: the men are digging busily.

This is one of many panels dating from the years in which Seurat still seems to be groping, still laboring under three influences—that of Millet, apparent in some figures of stooping peasant women; that of Courbet, which we shall see in *The Stone Breaker;* and that of Van Gogh, most apparent here in the jaggedness of the composition.

All this will gradually be assimilated in the course of studies of the industrial suburbs and the banks of the Seine, preliminary to *Bathing at Asnières,* Seurat's first major work. Here we have a kind of dramatic counterpoint between the hearselike cart and the toiling man overshadowed by it. The laborer in the straw hat seen half-length at right is quite striking.

We have seen that Seurat displayed interest in the life of workingmen. Claude Roger-Marx has justly observed that, "solely preoccupied by gradations and contrasts," in his portrayal of a stonemason on his ladder, a peasant in the fields, or a quarry worker, "he achieves unexpected dramatic power. His figures move about in a kind of tragic silence, enveloped in a mysterious halo."

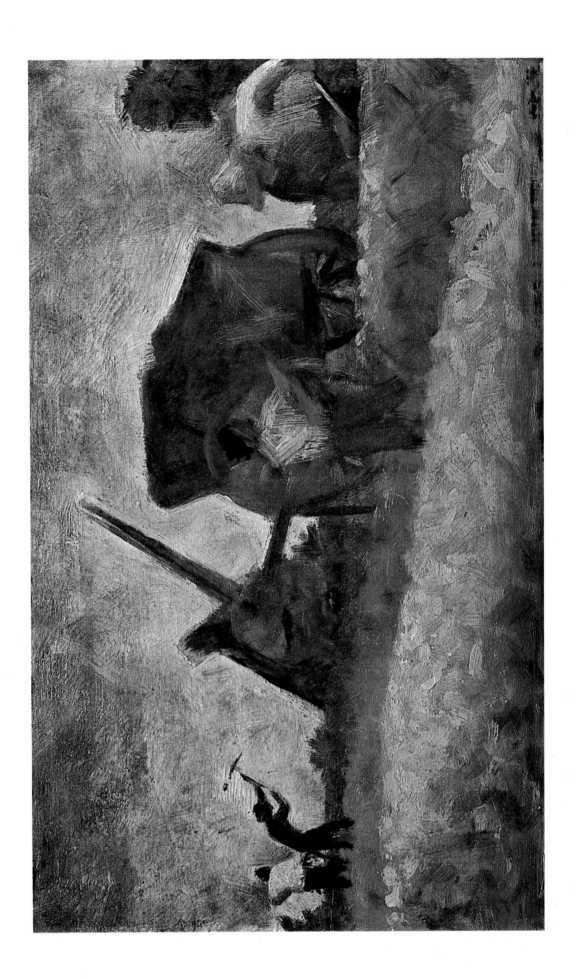

Painted about 1883

INDUSTRIAL SUBURB

Oil on canvas, 12 3/4 × 16 1/8". Unsigned

Collection Pierre Lévy, Troyes

Like Signac and Luce, Seurat was drawn to and moved by the laboring classes—factories, the shabby industrial suburbs of Paris, and the squalid conditions of workers' lives. What he may have thought of all this never appears explicitly in his work. As in all other connections, he is reticent in exhibiting strong feeling. This restraint is all the more effective in his treatments of workers and peasants—the objectivity he brings to bear is much more valuable than any amount of emotional indignation or theoretical condemnation.

This is an unforgettable picture of an industrial suburb with its angular, ugly buildings. The many verticals are dominated by the single smokestack in the distance. The flat foreground with its poor, stunted vegetation implies the chemical pollution of the atmosphere.

Seurat places the viewer in the heart of the no man's land that rose around big cities in the last century. It is a man-made desolation, malodorous and unhealthy. The artist has skillfully extracted a harsh poetic quality from squalor. The painting, with its narrow range of muted tones, was first owned by Félix Fénéon. John Rewald dates it 1882.

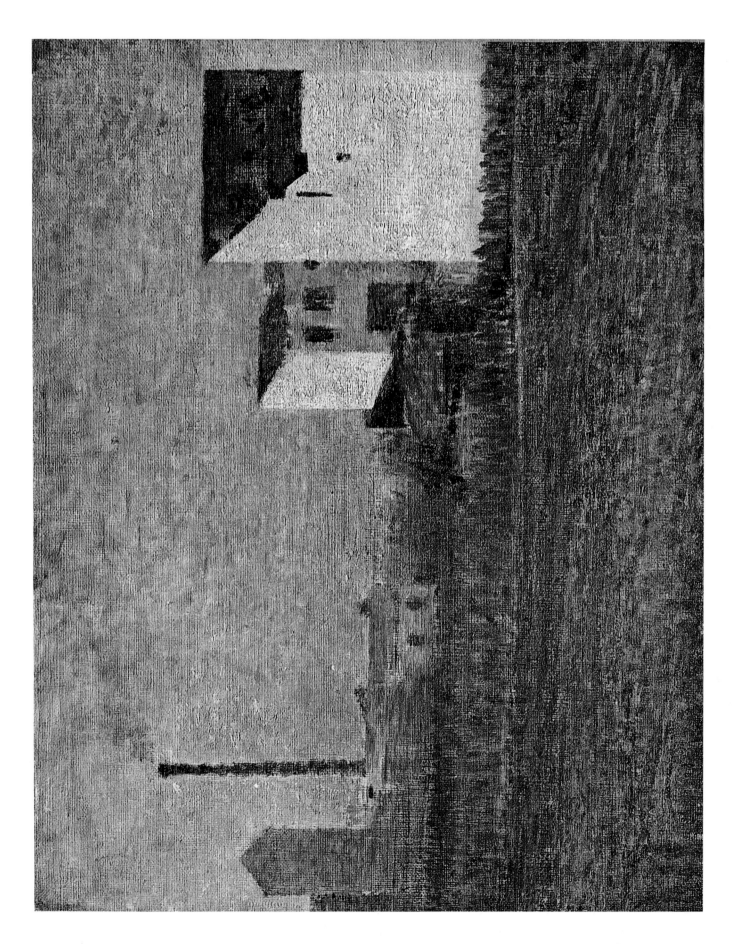

Painted 1883

FISHERMEN

Oil on panel, 6 1/4 × 9 5/8". Signed and dated, bottom right

Collection Pierre Lévy, Troyes

This is one of the studies of river scenes which preceded *Bathing at Asnières*. It shows very clearly Seurat's development away from line to silhouette. The fishermen holding their poles parallel to the water look like figures in a shadow play. The artist here sums up a quintessential experience with a minimum of brush strokes and hardly any descriptive apparatus.

The men are waiting, quiet and motionless, their dark silhouettes blending into the riverbank. With the infinite patience of their breed they sit there, not even moving their heads. All this is conveyed plastically, suggested by spots of color, tones, and planes against the rippling stream. The boat is receding into the shadows of approaching night.

This is not Rembrandt's chiaroscuro, but something else entirely. The planes have been reduced to their tones, without further detail, and yet we can make out the individual expression of each figure.

In works such as this, Seurat reveals a sensitivity to the silhouette which will characterize much of his later work. The technique for rendering dark forms against a light ground, if it has a source outside of Seurat, must derive from Daumier.

62

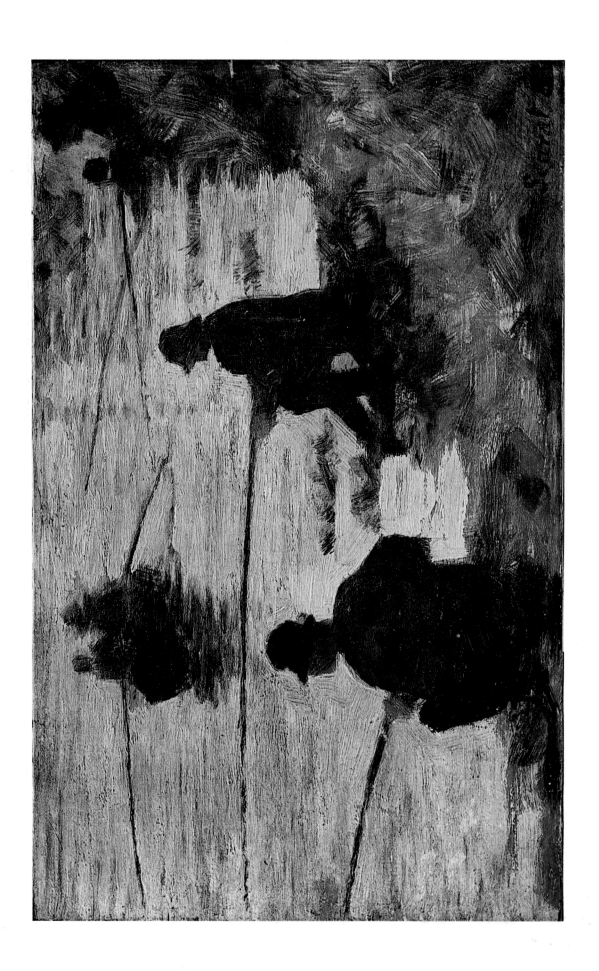

Painted about 1883

HORSES IN THE WATER
(Study for *Bathing at Asnières*)

Oil on panel, 6 × 9 3/4". Unsigned

Formerly Collection Cristabel, Lady Abirconway, London

This is one of many preliminary studies for *Bathing at Asnières*, and one of four including horses; it is a little gem.

Seurat was familiar with Corot's remarks on painting, including this one: "It seemed to me very important to prepare a painting or a study for a painting by first indicating the most vigorous tones (assuming that the canvas is white) and proceeding systematically thereafter until the palest tone is reached. I would distinguish twenty degrees on the scale from the most vigorous to the lightest tone. . . . Always keep in mind the picture as a whole, the striking elements of the scene. Never lose sight of your first impression, what it was that actually moved you."

When he began a painting, Seurat never forgot to put down his darkest and his lightest tones before anything else. Once he had these two poles to be guided by, the rest of the picture fell into place and he could organize a gamut of half tones and nuances.

This small panel is extraordinarily luminous. Seurat's brush stroke is here gaining discipline: given free rein in the foliage, it is applied horizontally on the water.

There is great sureness in the inverted-triangle composition, and in the richness of the modulations and reflections. Together they make this little picture a marvel of life and color.

This is perhaps the finest of the twenty-five studies for *Bathing at Asnières*. Seurat wondered a long time whether he should place the black horse and the white horse together or separately, but in the end left them out entirely.

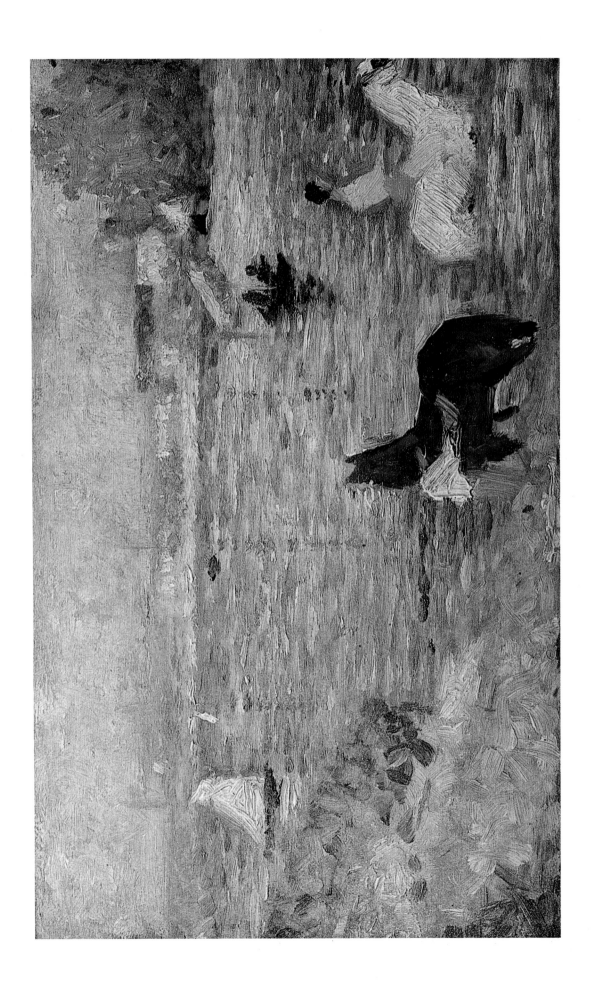

Painted 1883–84

THE BANK OF THE SEINE
(Study for *Bathing at Asnières*)

Oil on panel, 6 3/8 × 9 7/8". Unsigned

Private collection, Paris

This is another of the oil studies for *Bathing at Asnières*. The seated figure, his leg bent into an acute angle, is to become the main element in the final version, where he appears (in a slightly different pose) at the center. The artist will keep the sloping bank and add the figure of a man in a derby hat lying on the grass next to a pile of clothes. He will also keep the sailboat, though it will be at a greater distance.

The brightest point in the foreground (which is painted in neat, quick strokes) is the shirt of the seated man. The water is rendered by fairly pronounced lines (soon to be transformed into luminous reflections). The horse, the neck and head of which appear at lower right, will be replaced by a boy cupping his hands and hooting in imitation of a boat horn.

This very rough, loosely organized sketch gives little notion of what the big canvas will be like. The figures seated on the grass are watching those in the water. We have not yet been taken "inside" the scene, as we will be in the final version.

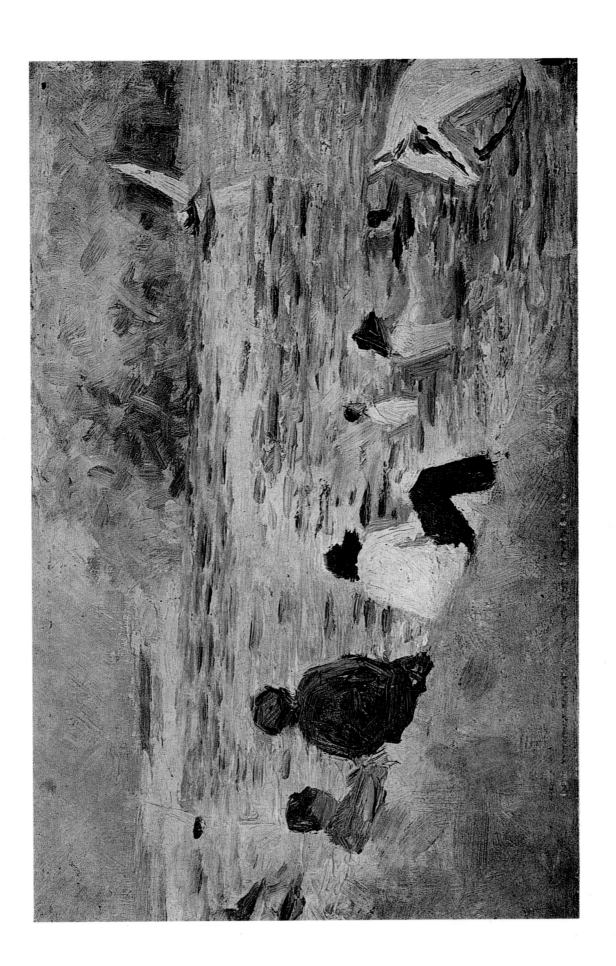

Painted 1883–84 (retouched 1887)

BATHING AT ASNIÈRES

Oil on canvas, 79 × 118 1/2". Signed, bottom left

The National Gallery, London

Planning the composition of *Bathing at Asnières,* Seurat made field trips to the island of La Grande Jatte; the approximate site can be checked on any map of the Paris suburbs. But this first of his big canvases was executed in the studio, merely drawing upon the preliminary studies made outdoors.

"Coming from Paris," Beaubourg wrote to Coquiot, "the island was on one's right, more or less opposite the spot where people swim on Sundays, halfway between the Bineau bridge and the northern tip of the island, just where the river makes a sharp bend toward Courbevoie and Asnières. Seurat was often to be seen painting there."

Jules Christophe left this short description of *Bathing at Asnières:* "Water, air, the railroad bridge in the distance, boats, shimmering trees, seven men and boys in various stages of undress, either in the water or sprawled upon the grass. Not many people saw the canvas (at the Salon des Indépendants it was relegated to the bar), but it represented a great deal of work."

According to Signac this large composition, for which Seurat had made so many preliminary drawings and oil studies, was painted "in broad, smooth brush strokes placed atop one another, in a palette of ochers and more vivid colors. Like Delacroix, he blended his colors in individual areas." Signac goes on to sum up Seurat's method as follows: "Observance of the laws of contrast, methodical separation of the elements (light, shadow, local color, reactions)."

This is a hazy work, saturated with summer heat. In the distance loom factories and their smokestacks. We feel the oppressiveness of the atmosphere, the immobility of the scene. The light here weighs more heavily than the shadows. In an article, Arsène Alexandre refers to the enormous amount of work that went into this painting: *"Bathing at Asnières* made it clear that Seurat was the one younger artist capable of putting his back into it—one of the few capable of organizing a vast composition utilizing hitherto unknown techniques."

The many partial studies that went to produce this work have been brought together into a coherent, unified whole. The summer silence is broken only by the boy who is cupping his hands to make a sound like a boat horn. This is vacation time, rest after toil. The distribution of blacks and whites, light tones and dark, straight and curving lines (the latter predominating) is very elaborate. The light, the sun, the greenery, the buildings, the water, the people, the boats gliding along in the background— everything gives off the torpid heat of a summer afternoon.

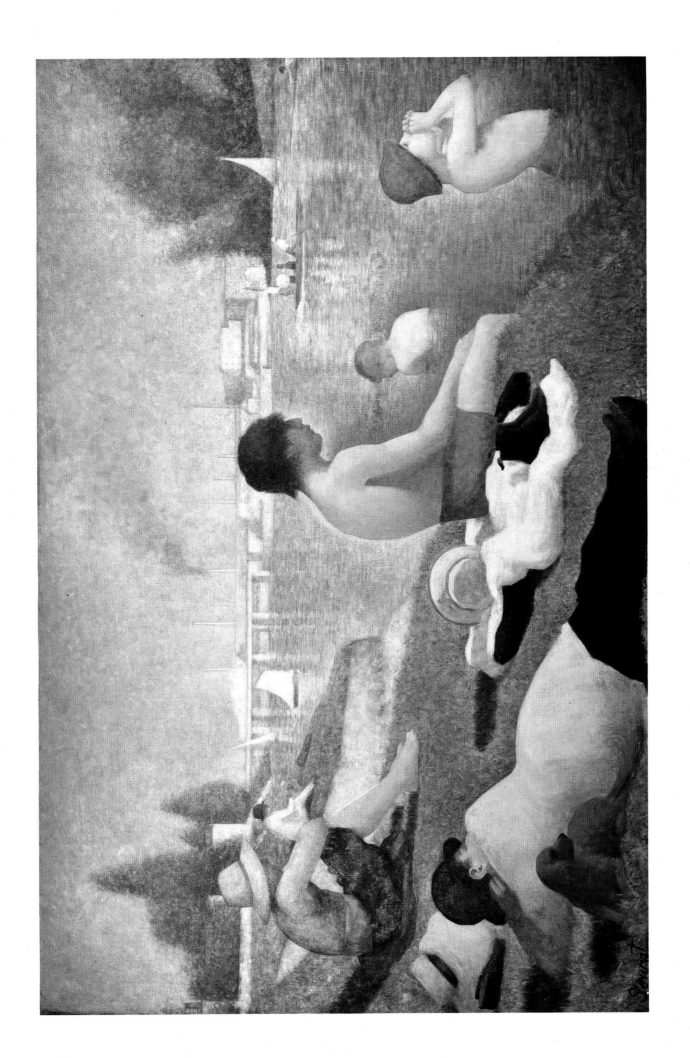

Painted 1883–84 (retouched 1887)

BATHING AT ASNIÈRES

(Detail: seated figure at right center)

The National Gallery, London

Seurat made two preliminary drawings in conté crayon for this figure of a young swimmer sitting on the riverbank. One of these (formerly in Fénéon's collection, now in that of Gerard Bonnier, Stockholm) is a nude, in almost exactly the position of the figure in the painting. The other drawing, now in the Yale University Art Gallery, shows the same figure wearing a hat, with knees drawn up. Seurat also made several drawings of the derby-hatted man reclining in the foreground, and the young bather standing bemusedly in the water.

Seurat had made a thorough study of Puvis de Chavannes, who, throughout this heyday of Impressionism, labored to restore formal composition to painting (despite what Meyer Schapiro calls the weakness of his "imagery"). It was to Puvis, whose pictorial organization he imitated, that Seurat owes this way of placing every element at just the right point in the picture. Seurat owed nothing, however, to Puvis' sense of color, which was as dubious as his sense of plastic values.

The painting was owned by the artist's mother, then jointly by Émile Seurat and Léon Appert, before Félix Fénéon acquired it. Trublot (Paul Alexis) commented in the *Cri du Peuple:* "This is a fake Puvis de Chavannes. . . . But the work is so convincing that it is almost moving, and I shan't make fun of it." According to Jacques-Émile Blanche, the painting has lost a great deal of its original luminosity and resonance.

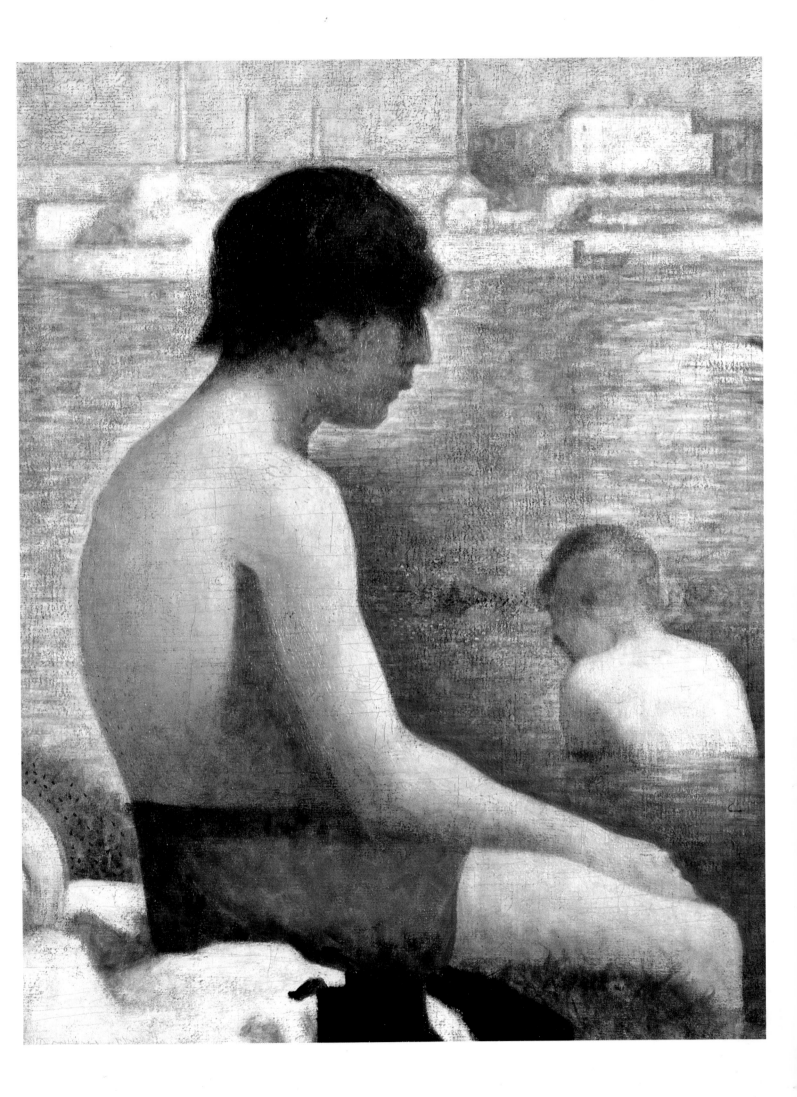

Painted about 1884

THE STONE BREAKER

Oil on panel, 6 3/8 × 10". Unsigned; name stamped on bottom right
The Phillips Collection, Washington, D.C.

This work is characteristic of Seurat's early period. Though in an entirely different technique, it brings to mind Courbet's *Stone Breakers*. But Seurat took his subject from direct observation of the workingman's life. While Courbet's stone breakers look motionless, Seurat's busy figure is very much alive. In his ability to capture the movement of a figure, Seurat is sometimes close to Daumier. His field and factory workers live and move about in light.

This work has a stillness and banality very true to its subject. Seurat noticed that a man breaking stones doesn't exert great muscular force, but rather relies on his skill with his implement to accomplish the job. There is accuracy of observation here, and the warm palette of unexpectedly luminous colors makes a glowing composition. The light and heat of the day are concentrated in the light tones.

This panel is one of many studies executed at Le Raincy in the same period, among others *Gardeners* and *Peasant with a Hoe*. The latter brings Millet to mind for its subject, but it differs in both pose and technique.

Painted about 1884

RUE SAINT-VINCENT, MONTMARTRE, IN SPRING

Oil on panel, 9 7/8 × 6 3/8". Unsigned
The Fitzwilliam Museum, Cambridge, England

The Montmartre shown here is almost open country. Seurat took pleasure in the green luxuriance of this little street, winding its way between walls and gardens. The same street was celebrated a little later in a song by Aristide Bruant, but here it has a very different character.

The composition presents a fairly rigorous geometric pattern: verticals with bars of shadow lying across the street. The geometry is concealed, however, by the foliage, the air, and the light. Seurat has been called a forerunner of abstract painting but, while this is true, it would be just as true to say that his paintings were distillations from nature. Even small panels like this one were composed with scientific rigor, but the compositional scaffolding was covered over with colors, tones, lights. His method is to contrast a carefully constructed landscape with an improvisation of fresh, vibrant color.

This shimmering structure brings to mind Claude Debussy, another pioneer of a new technique, who nonetheless never sacrificed sensibility to it. Both artists renewed the practice of their respective arts—the composer with his diatonic scale and his employment of dissonance, the painter with his return to composition and his Chromo-Luminarism. The formative period of both men falls between the Decadents and the Symbolists in literature, and both were attracted more by northern France than by the south. However, the painter antedates the composer by a few years. Seurat was already dead when Debussy's real career began: the *Prelude to the Afternoon of a Faun* dates from 1894.

Painted 1884–85

STUDY FOR "LA GRANDE JATTE"

Oil on panel, 6 × 9 3/4". Unsigned
Private collection

Here we have an early version with figures for the big painting, also now in Chicago. The seated woman in the foreground will be replaced by the standing woman leading a monkey on a leash. The woman slightly behind the first, here shown walking from left to right, will be replaced by two seated figures, one of whom, on the left, holds a parasol. The man standing on the right will be directly behind the woman with the monkey, and other figures, who will give air and depth to the composition, have still to be added at the center.

More and more, Seurat's painting is approximating the style of his drawings. By merely applying spots of color he manages to suggest the boundaries of the form, the meaning of the attitudes, and even facial expressions. All this is well organized and full of life in sunshine and shadow, with silhouettes at right and left to set off the scene.

This oil study (formerly owned by Maximilien Luce) is the one that offers the greatest contrast with the final version—to such a point that it could pass for another composition entirely. Instead of making his figures move from right to left, Seurat here interrupts this movement with the woman standing center right; she reverses the movement and draws attention in the opposite direction.

It is very instructive to compare the two pictures. It can be seen that the slightest change can upset a plastic organization. In the version reproduced here, the background is oddly simplified. A broad area of light spreads behind the foreground silhouettes, whereas in the final version of the painting we have a real sequence of planes in depth, with a hierarchic procession of figures, shadows, and light. On the other hand, the earlier version has perhaps a more brilliant and spontaneous coloring.

Later, Henri de Régnier will evoke the Seurat of this period: "Exactly like the Sunday strollers/From Montrouge or from the Place Blanche,/Who take the omnibus to the Bois de Boulogne,/And then alone, in pairs, or in threesomes,/Go on to spend the afternoon in the bracing air/Of islands like Puteaux or La Grande Jatte."

Painted 1884–85

LADY WITH A MONKEY
(Study for *La Grande Jatte*)

Oil on panel, 9 3/4 × 6 1/4″. Unsigned
The Smith College Museum of Art, Northampton, Mass.

This is a synthesis of countless studies and drawings Seurat made for the figure of the woman in the right foreground of *La Grande Jatte*.

In some places the brush barely touched the panel. The artist's chief interest is concentrated on the black in the lady's jacket, the diagonal of the parasol contrasting with the rigorous vertical of her profile, and the perspective of trees. A distinctive feature of this painting is that it looks like a sketch, and shows no trace of the work already devoted to this motif. The underlying plastic considerations can only be guessed at.

The artist, while composing in the contemporary fashion, succeeds in going beyond it, integrates it in his own order. "A derby hat by Degas is never ridiculous," Signac wrote. "It achieves style by its pictorial quality. The hats by Dagnan-Bouveret [an academic painter of the period] make us laugh." Similarly, Seurat repudiated the picturesque. Everything he paints takes on his own style.

Charles Angrand, who watched him at work on the island of La Grande Jatte, says that "Laying out his palette, Seurat always observed this order: three squeezed-out strips of white pigment near the thumb, each to be mixed with one of the primary colors—red, yellow, and blue."

In the definitive version of *La Grande Jatte* Seurat added a man in a top hat behind the woman with the monkey.

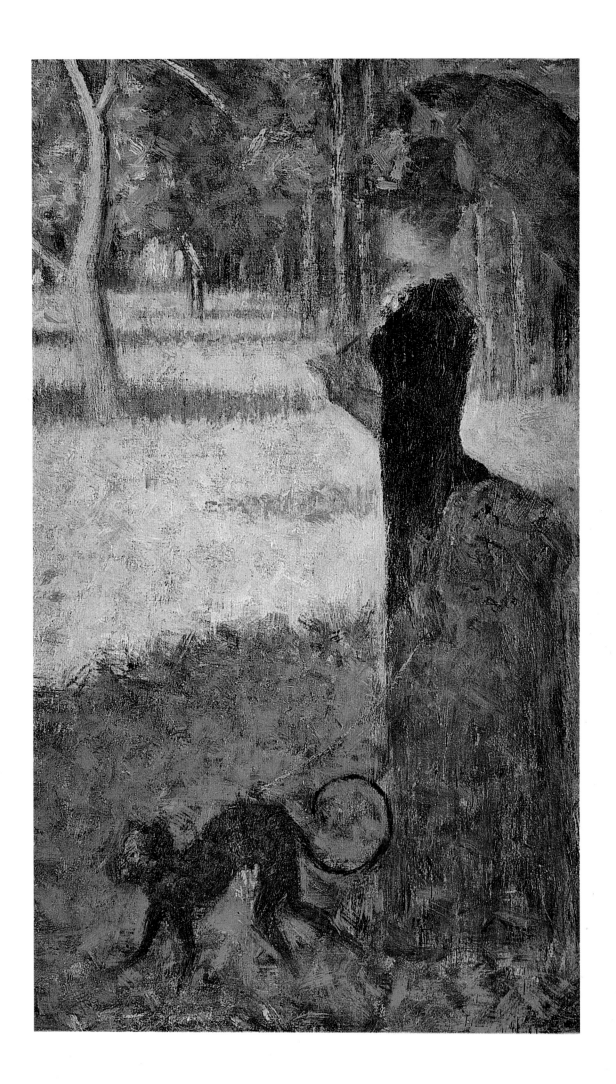

Painted 1884–85

AN AFTERNOON AT LA GRANDE JATTE
(Study for *La Grande Jatte*)

Oil on canvas, 26 3/4 × 41". Unsigned

The Metropolitan Museum of Art, New York. Bequest of Samuel A. Lewisohn, 1951

This was Seurat's last study prior to the final version. It is a gem of scintillating light and joy, of contrasts between light and dark (both tones and hues), a sketch for the whole picture with everything in its place. It is a highly musical work, in which time enters space on silent feet in the form of the woman with the bustle, dressed in the fashion of the day, whom the painter turned into a kind of Astarte.

From the dark tree trunk to the strongest lights--the houses and built-up riverbank in the distance, the sailboats—this is a crescendo of luminosities, colors, and sensibility. Everything in it has been grouped with great art, composed without seeming to be.

Between this study at the Metropolitan and the definitive painting in Chicago, several details will be altered. The reclining figure at left in the jockey cap will be more sharply rendered, as will also the little girl running among the trees. The background planes will gain greater depth and luminosity. Finally, the alternation of lights and shadows will be more elaborate in the Chicago painting. On the other hand, the freshness, spontaneity, subtle overtones, and sonorous density of the pigment in this canvas are not always to be found in the big canvas in Chicago. The latter to some extent makes up for this loss of youthful qualities by greater clarity of organization and articulation.

Puvis de Chavannes used to prepare his huge murals by studies representing a numbered area of the finished work. Seurat never made this mistake. He knew that the size of any picture demands a specific mode of composition and expression. This is why his big canvases and his preliminary studies for them possess their own artistic value, creative originality, and individual flavor, and why these qualities are never identical nor identically placed.

This great work was formerly owned by Félix Fénéon.

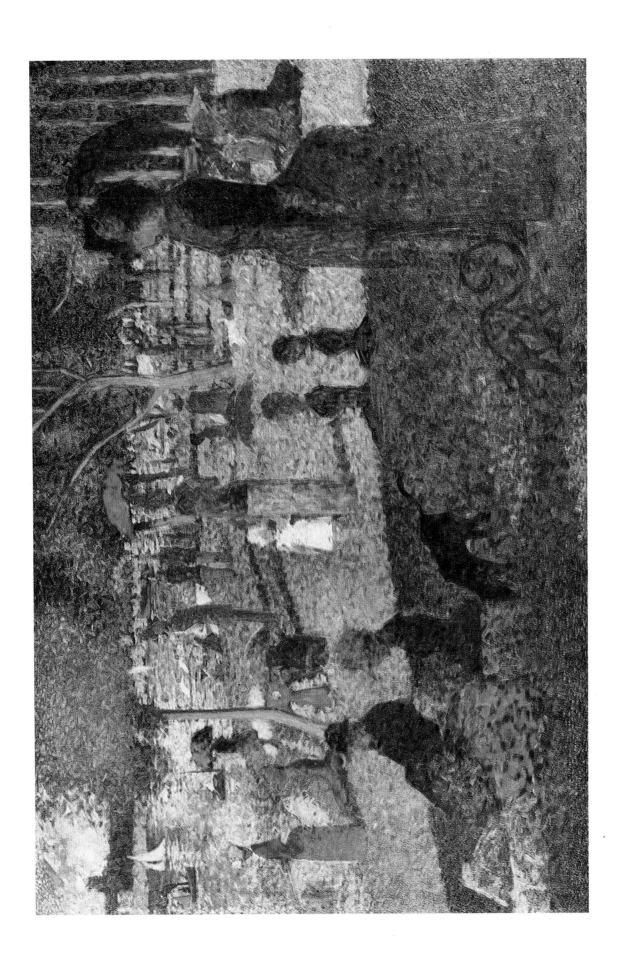

Painted 1884–85

A SUNDAY AFTERNOON ON
THE ISLAND OF LA GRANDE JATTE

Oil on canvas, 81 × 120". Signed, bottom right

The Art Institute of Chicago. Helen Birch Bartlett Collection

To comment on this vast canvas where Seurat for the first time succeeded in applying, with scientific rigor, the theory of optical mixture by the division of tones—a technique which Rubens, Watteau, and Delacroix had employed intuitively—one cannot do better than to quote the following text by Jules Christophe. It was published in *Les Hommes d'aujourd'hui*, No. 368, an issue devoted to Seurat. The list of motives was dictated and revised by the artist himself:

> Under a blazing midafternoon summer sky, we see the Seine flooded with sunshine, smart town houses on the opposite bank, and small steamboats, sailboats, and a skiff moving up and down the river. Under the trees closer to us many people are strolling, others are sitting or stretched out lazily on the bluish grass. A few are fishing. There are young ladies, a nursemaid, a Dantesque old grandmother under a parasol, a sprawled-out boatman smoking his pipe, the lower part of his trousers completely devoured by the implacable sunlight. A dark-colored dog of no particular breed is sniffing around, a rust-colored butterfly hovers in mid-air, a young mother is strolling with her little girl dressed in white with a salmon-colored sash, two budding Army officers from Saint-Cyr are walking by the water. Of the young ladies, one of them is making a bouquet, another is a girl with red hair in a blue dress. We see a married couple carrying a baby, and, at the extreme right, appears a scandalously hieratic-looking couple, a young dandy with a rather excessively elegant lady on his arm who has a yellow, purple, and ultramarine monkey on a leash.

There was public resistance to the picture at first, Arsène Alexandre tells us: "Everything was so new in this immense painting—the conception was bold and the technique one that nobody had ever seen or heard of before. This was the famous Pointillism."

When exhibited at the Indépendants, the work aroused sneers and indignation. "There were outcries," Christophe goes on to say, "but by standing its ground the picture's revolutionary character won out in the end. Its success was immediately hailed in *La Vogue*, to which Félix Fénéon contributed a lively, logical, and well-informed article."

Prior to its acquisition by the Art Institute of Chicago, the painting was owned successively by Seurat's mother, Maximilien Luce, Edmond Cousturier, and Charles Vildrac.

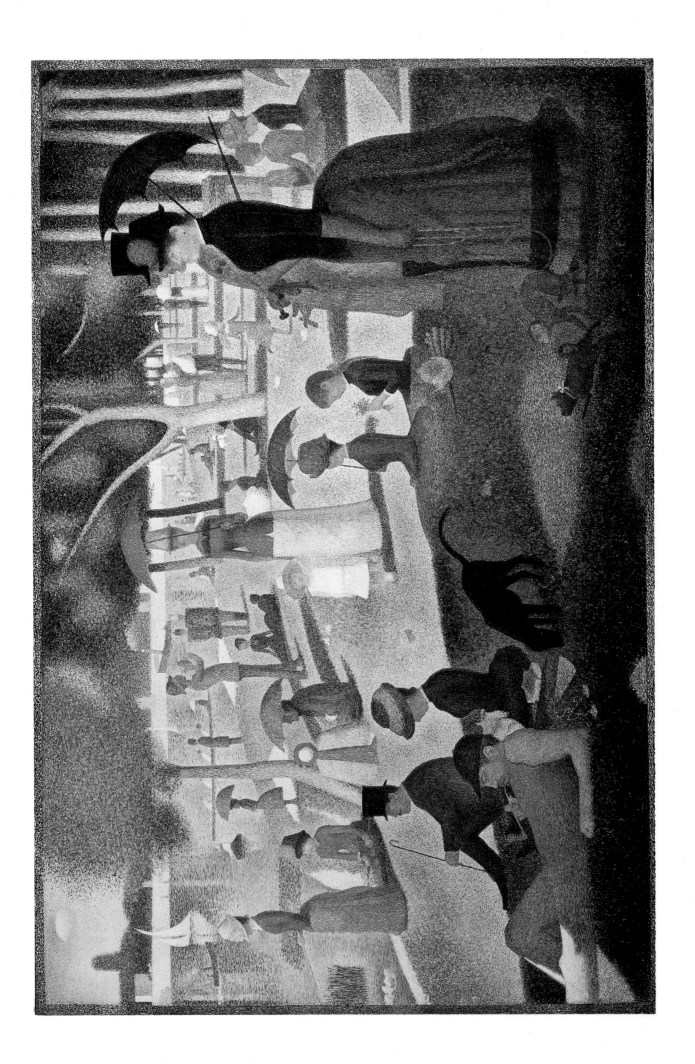

Painted 1885

THE BEC DU HOC, GRANDCAMP

Oil on canvas, 26 × 32 1/2". Signed, bottom right

Tate Gallery, London

In this work the painter is handling masses. The main diagonal curves across the canvas. The earth and rock are bearing down with all their weight upon the sea that washes them. The effect is one of a steep precipice, an abyss.

The distance is given by the birds overhead and the boats on the horizon. We see how Seurat has kept strictly to the most elemental aspects of his subject—water, air, rock. Like some work by Bruegel the Elder, this one suggests space, immensity.

"M. Seurat's seascapes give off calm and melancholy," Fénéon wrote. "They ripple monotonously as far as the distant point where the sky comes down. One rock rules them tyrannically—the Bec du Hoc."

The range of proportions and dimensions has been admirably rendered from the large to the small, from the heavy to the light, from the luminous to the shadowed. Seurat has varied his brush stroke to suit what he evokes, and he has varied his punctuations with great flexibility. He has suggested a kind of dizziness at the spectacle of infinity.

The technique has something of the Japanese print. The immensity is conveyed by contrasting elements—the flight of birds, the barely visible tiny boats, the surface textures of the sea, and the jutting rock above it.

To give mobility to the sea Seurat has recourse here to a particular technique: he interrupts his horizontal brush strokes with a multitude of tiny dotlike verticals, thereby producing an original throbbing.

One sketch for this painting exists, which shows what the artist's eye had actually caught, whereas in the final version all is carefully composed.

Seurat sold this canvas for 300 francs in 1887.

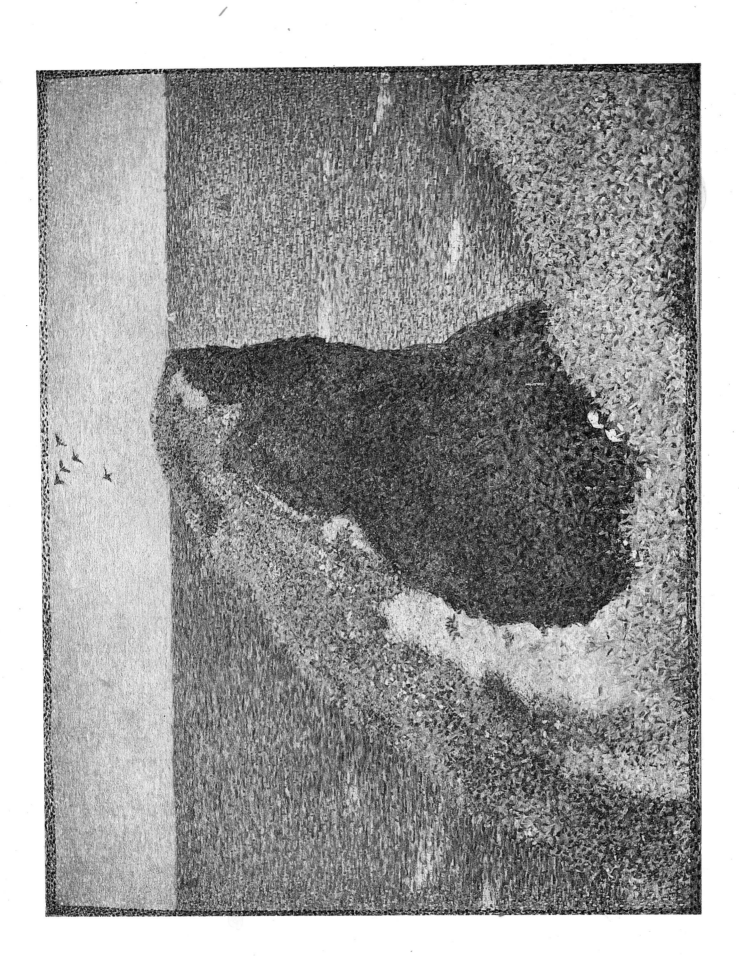

Painted 1886

DOCKSIDE AT HONFLEUR

Oil on canvas, 31 7/8 × 25 5/8". Signed, bottom right

Kröller-Müller State Museum, Otterlo, The Netherlands

This is an invitation to travel. Seurat might almost have had in mind these lines by Baudelaire:

> See, on the canals
>
> Those sleeping vessels
>
> Of vagabond spirit.

With its masts and cables, this swift courser of the high seas, the heavy ship with dark hull at the center of the canvas, seems already laden, ready to depart once more for faraway ports. The ship in the right foreground, however, tied with cables to the stanchion, makes one think of a slave in chains.

The painting is very straightforward, presenting few technical problems. The scene reflects every conceivable reminiscence and dream of which the sea is the cradle and dispenser.

Émile Verhaeren owned this picture as well as *The Poorhouse and Lighthouse at Honfleur*. Referring to the work shown here, Seurat wrote him in January, 1887: "I have left your canvas in the same frame you saw it in." Concerning the title, he comments: "A bit of dockside—but not just any bit, any dock. . . . If I remember correctly, I must have written the title of your painting in blue pastel on the back of the canvas, the very day you came to see me." In another letter, in reply to a remark made by the Belgian poet on this canvas, Seurat wrote: "I agree with you: *The Lighthouse* took me two months to paint, *The Dockside* only eight days. In fact, I remember mentioning this when I gave you the painting. I consider this one a big sketch. So we'll agree on a friendly price."

86

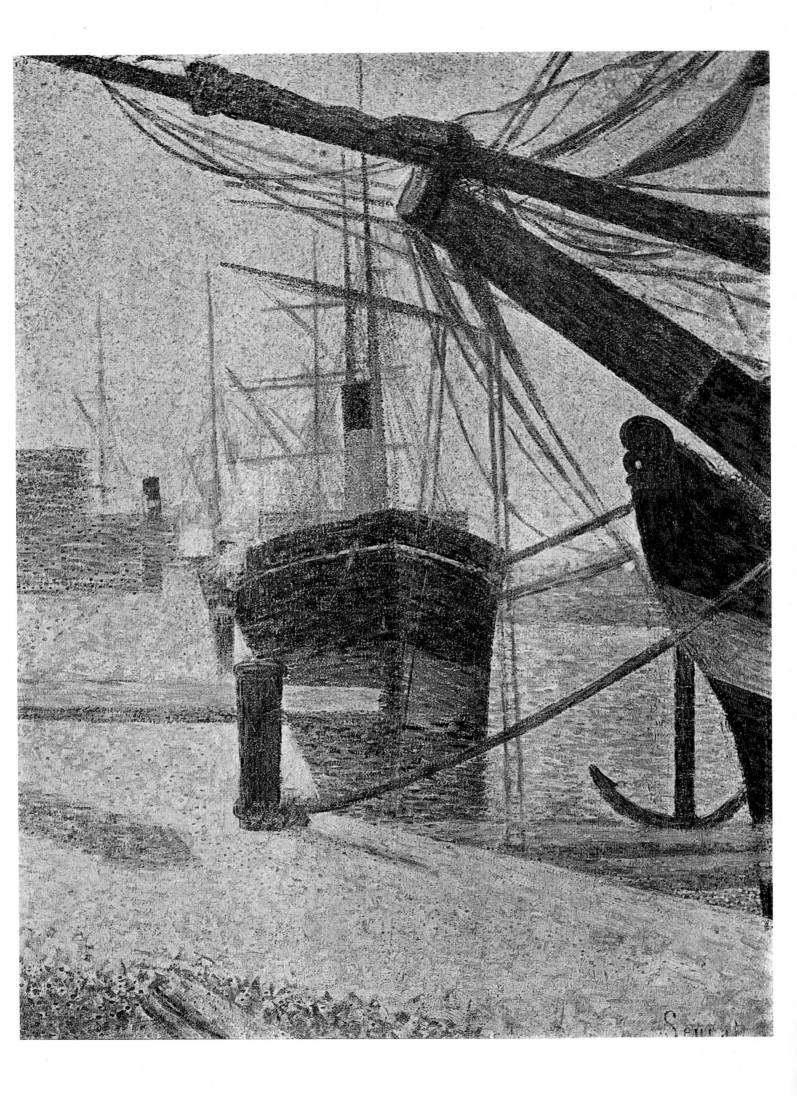

Painted 1886

EVENING, HONFLEUR

Oil on canvas, 25 1/4 × 31 1/2". Signed, bottom right
The Museum of Modern Art, New York. Gift of Mrs. David M. Levy

In presentation, arrangement, and autographic style, this work is very
like a Japanese print. The whole scene is rendered with a very few touches.
It is a restful painting. Long strips of cloud and water are intersected with
the short verticals of the pilings, and of the rocks, lighted from behind,
at the right.

Seurat has dared to paint a sunset in frontal view—this is the hallmark
of a great artist, for it is not for nothing that "daubers" are fond of the
motif: it lends itself to every sort of vulgarity.

A study for this painting, now in the Jean Pacquement collection in
Paris, shows how carefully Seurat composed his works. The study is a
mere casual notation from nature, a rough sketch. Comparing it with the
painting, it can be seen how much Seurat added in the way of construction,
organization, the picture's very rhythm. Here the artist succeeded in
painting a scene where there is nothing to see—a few pilings, a rock at the
edge of the water, the sky and the sea. But within these broad surfaces
he makes infinite modulations and creates all sorts of tensions of light and
color. Now he suggests, now he emphasizes, and gives an excellent idea
of the coast's remoter stretches. Little by little, the canvas comes alive
with transparent clouds and the light dancing on the water. The dots
endow with vibration the very subtle coloring with which the artist
shows us the moment of nightfall, when the clouds are darkening in the
sky's last glow, the light on the sea is growing cold, and shadows steal
over the land.

Painted 1886

SHORE AT BAS-BUTIN, HONFLEUR

Oil on canvas, 26 3/8 × 30 3/4". Signed, bottom right

Musée des Beaux-Arts, Tournai, Belgium

This canvas has been built on the diagonal of the cliff running down to the beach. It is another summer work, done during vacation time when the artist would get away from Paris in order to "freshen his eye." Nearly all these landscapes are clean and sparkling, tinged with blue.

This song of praise to summer light on water and land is one of Seurat's finest paintings. Once more Seurat's technique adapts to the various elements suggested: the vegetation, the cliff, the sandy beach, the sea, the ships in the distance, the sea mist. Close scrutiny of this canvas reveals a great diversity of brush strokes. Signac, for instance, is much more predictable in the way he piles up his uniform rectangles of color. Seurat lets himself go, allows himself to be enchanted. There is always a point where the artist in him gets the upper hand over the craftsman, and, without eclipsing him entirely, exalts him.

Each of the canvases Seurat executed during his holidays formulates and solves a different problem.

There is an oil-panel study for this painting in the Baltimore Museum of Art.

(Bottom)

Painted 1886

END OF THE JETTY AT HONFLEUR

Oil on canvas, 18 1/8 × 21 5/8". Signed, bottom right
Kröller-Müller State Museum, Otterlo, The Netherlands

This painting was formerly owned by Paul Adam, whose early praise of Seurat was extremely prophetic. We have the whole sea here—the small dune, the lighthouse on the jetty, the open sea in the distance.

All this is done with a few touches and one or two verticals. The emphatic dark tone of the piling on the right holds the design in balance all by itself; it opens the picture out to depth. The light mist and the salt air seem to come right up to the viewer's face.

The delicacy and sparseness of the muffled tones, the way the over-all drawing and the sensitivity of the brush strokes emerge simultaneously, how the feeling expands, not just in space but also in time, the mist, the marvelous specks of color—it is an enchanting picture.

The painter has entered directly into dialogue with these things; like all shy persons, he was given to silent contemplation. At the spectacle of nature, he grew enthusiastic. Henri de Régnier pointed it out in a poem:

> An ardent soul dwelt in you, Seurat.
>
> I've not forgotten. You were grave, untroubled,
>
> Gentle, taciturn. You knew how much we squander
>
> Of ourselves in idle, rumbling words.

Here the painter held converse with water, earth, and sky.

(Bottom)

Painted about 1887

THE SEINE AT LA GRANDE JATTE IN THE SPRING

Oil on canvas, 25 5/8 × 31 7/8". Signed, bottom right

Musée d'Art Moderne, Brussels

Several years before he actually painted this canvas, Seurat sketched out a first idea for it: *The Canoe.* But, whereas the latter conveys the impression of gliding flight—a fleeting evocation of the passing of time—the Brussels painting is a vision of stability. The figure in the canoe, the boat with the white sail—these fleeting elements are here overshadowed by the static elements of the composition: its horizontality, the wide bright strip of the far quay over the water, the tree with the bifurcated trunk, the grass in the slanting foreground area.

Charles Angrand once owned *The Canoe;* he himself had also painted this motif, with Seurat, at this very spot. In a letter to Lucie Cousturier (July 4, 1912) Angrand recalls how he and Seurat "worked side by side on La Grande Jatte through one whole spring." He mentions the "tree in sunshine" of which he had a sketch.

The painting shown here breathes the same joy in living with which Seurat always endowed the banks of the Seine. It has the crystalline clarity of a fine spring day.

Painted about 1887

THE BRIDGE AT COURBEVOIE

Oil on canvas, 18 × 21 1/2". Signed, bottom left
Courtauld Institute of Art, The Home House Trustees, London

What restfulness, what peace and quiet! We feel night is about to fall, the boats are already at anchor. This is one of Seurat's outstanding paintings in medium-size format.

It might just as well be titled "In Praise of the Vertical." A plumbline seems almost to have figured in the composition. Here is to be recollected what Humbert de Superville had written of the vertical: that it is the line of force, the line of authority and command. As against all this severity (masts and standing figures), the twisted tree trunk in the foreground takes on the happy contrast of a female curve, which brings out everything else.

But there is no need to analyze a painting composed so clearly. It is really a poem to approaching night. This is late afternoon, the dazzling sky still reflected in the water where the men fishing have cast their lines, the silence broken only by the arrival of the last boat. Smoke is drifting around in the midst of this untroubled splendor.

Two preliminary drawings for this canvas are reproduced in César de Hauke's book on Seurat's works. The first is a detail of the bridge, the second more like the painting, except that there is only one human figure.

The work shown here was formerly owned by Arsène Alexandre, one of Seurat's stanchest defenders.

Painted 1887

SEATED MODEL
(Study for *The Models*)

Oil on panel, 9 1/2 × 5 7/8". Unsigned

Musée d'Orsay, Paris

Each of the three figures in the large painting *The Models* was the subject of a preliminary study by Seurat. In these three panels now in The Louvre, where they are brought together within one frame (they were formerly owned by Madeleine Knoblock, Seurat's mistress, and then by Félix Fénéon), the painter's technique is perhaps most apparent. They are a good illustration of his Chromo-Luminarism, his way of setting his dots like a swarm of tiny bees around the form they generate and define. We can see how they are smaller or bigger according to where they occur, and how the form emerges out of these tremulous molecules. They are very much alive and respond to every vibration of light and sensibility. It is a technique that makes it possible for the painter to render softness without loss of precision, a sense of the dynamically alive without dissolving form.

The atmosphere is limpid—there is not a single line. Volumes are modulated with elegance and delicacy. The darkest area (the baseboard at the bottom of the wall) is close to the lightest (the cloth on which the woman is sitting). In this buzzing swarm of warm tones the model has the gracefulness of a classical statuette.

In the study shown here, the model is holding her ankle, whereas in the small copy of the final version in the McIlhenny collection in Philadelphia, as in the big painting in the Barnes Foundation, she is shown removing a green stocking.

The painted border was added by Seurat in 1890, as indicated by a penciled notation Fénéon made on the back of the picture.

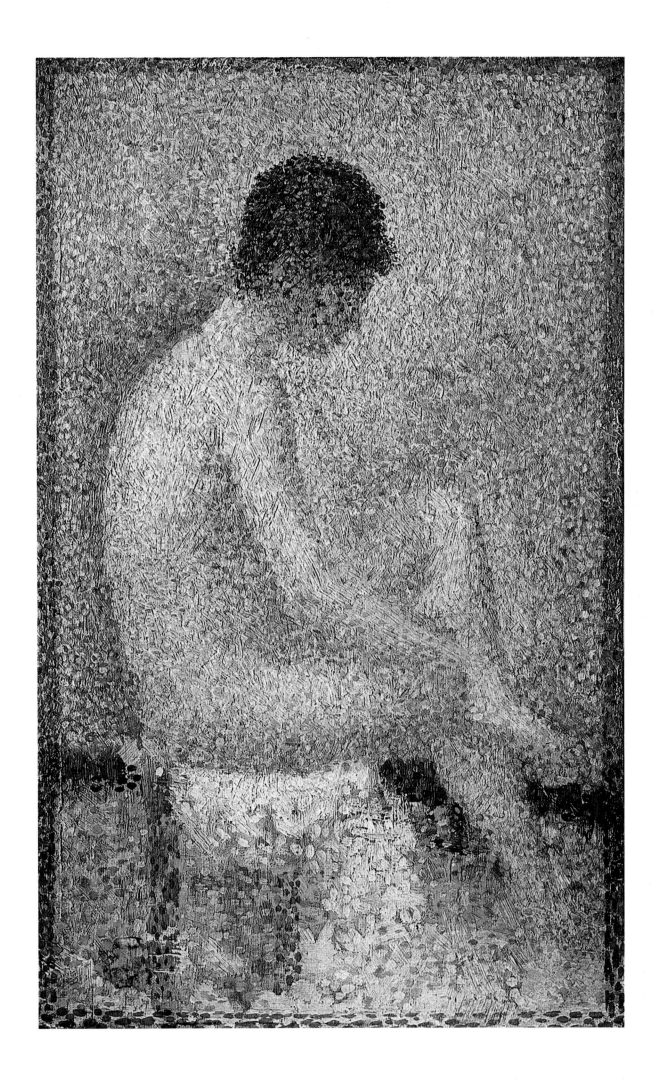

Painted 1887

STANDING MODEL
(Study for *The Models*)

Oil on panel, 10 1/4 × 6 3/4". Signed, bottom right
Musée d'Orsay, Paris

Here the technique takes on special relief. In some spots the outline draw-
ing can be perceived—this is one of the few figures for which the artist
made a line drawing. Treatment of volume, too, is elaborate, involving
a fairly pronounced chiaroscuro.

What we have here is really the quintessential model. More completely
than any other painter, Seurat has rendered the submissiveness, the absence
of all affectation, and the unawareness of their own charms that often
characterize professional models. By the same token, the artist makes it
clear that his only concern in relation to the nude standing in front of him
is to metamorphose her in some mysterious way into a new form, a girl
entirely of his own creation, one of the columns in the temple which the
finished painting represents to him.

According to Jules Christophe, this "slim, slightly knock-kneed model"
is "purer and sweeter than the idealized *Source* by Papa Ingres." There she
stands, "hands folded over the pudendum." Next year, Christophe goes
on to say, we will have "two pretty, younger girls, one viewed from the
back, the other in profile, and near them the gold of a few oranges, a green
stocking, a straw hat with white feathers, a purple parasol, other hats
and skirts, now blue now violet, a red sofa, and—at the far end of the studio,
shown slantwise—one section of the militant painting: *La Grande Jatte*."

Seurat made another oil study of this model and a conté crayon drawing,
now in the Robert Lehman collection, New York. This is the most thorough-
ly worked-out of the three. In blue letters, almost embossed as in a minia-
ture, we read at bottom right: "Seurat."

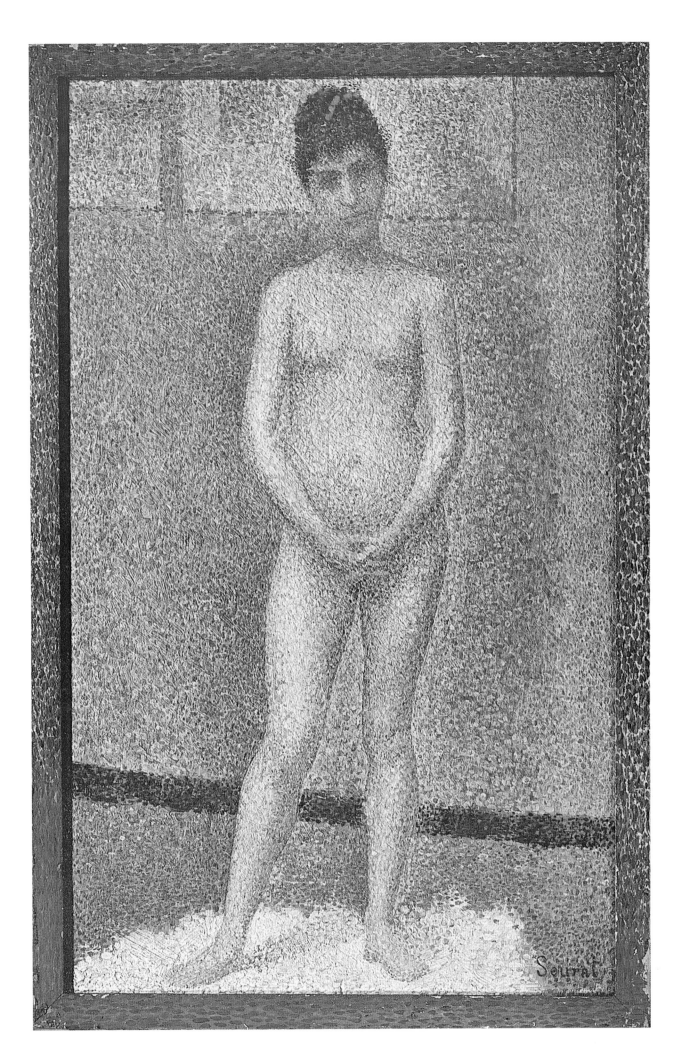

Painted 1887

SEATED MODEL, BACK
(Study for *The Models*)

Oil on panel, 9 5/8 × 6 1/4". Unsigned

Musée d'Orsay, Paris

This is by far the finest of the three studies for *The Models*. The form has the density of a Greek sculpture. The light barely touches the figure and reveals it at once both sharp and soft. There is almost no contour. Color is here at its zenith. The swarm of dots produces a marvelous spangled effect.

The brush strokes exhibit great variation: broad in the treatment of the hair, they are restrained in the area of subdued light, their separateness very marked, and extremely free in the section at the right.

As for the technique, it is on this admirable small panel, this incomparable sweep of female back, that we can best study Seurat's Chromo-Luminarism. Here the swarming dots seem literally to buzz.

Chaste, human, saddened, a bit sulky, these three models have been converted by the artist into officiating priestesses of a religion that completely divests them of erotic attraction.

The panel shown here was inherited, together with the final version of *The Models*, by Madeleine Knoblock, Seurat's mistress. Later it was acquired by Félix Fénéon, who also owned *Seated Model* and *Standing Model*.

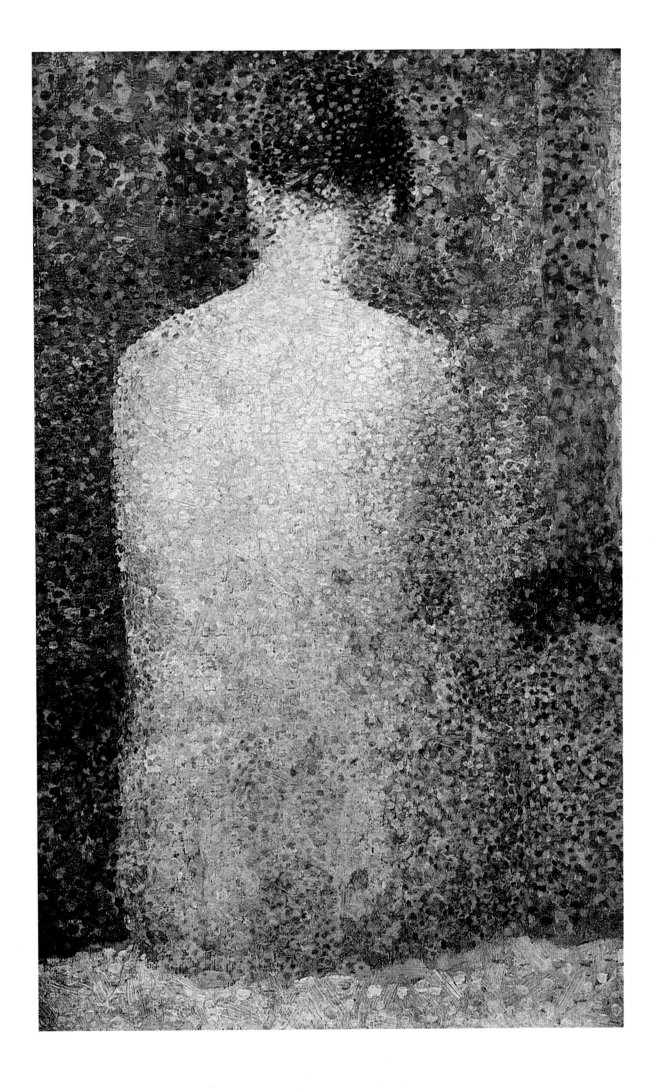

Painted 1888

THE MODELS
(Small Version)

Oil on canvas, 15 1/2 × 19 1/4". Unsigned
Collection Henry P. McIlhenny, Philadelphia

Here the model is shown, with great freshness and resonance, in the three stages: undressing (right), posing (center), and resting (left). The simultaneity with which the whole cycle has been conceived is admirable. The painting *La Grande Jatte* on the wall behind the model at left reminds us of the purpose of the exercise. In this studio scene the atmosphere is calm, untroubled.

This is a refined work. Seurat may have painted it at the urging of Félix Fénéon. The latter maintained that Pointillism could best justify itself when it suggested naturally smooth forms.

Seurat went through a long period of uncertainty about this painting and made several preliminary oil studies for it, and also drawings of the hat, coat, and the parasol against the stool, as well as of the standing model.

The definitive painting, in the Barnes Foundation at Merion, Pennsylvania, is much more studied, much more deliberate than the small version reproduced here—which, however, was painted *after* the big one. In it Seurat partly took into account Signac's criticism that the brush strokes in the "great empty spaces" of the Barnes version were too small.

Roger Fry greatly admired the musical composition of *The Models*, and said that it would be impossible to shift a ribbon or a button in it without unbalancing the whole work. A critic of the period described the figures as "lamentable rickety skeletons, daubed with every shade of the rainbow," whereas Paul Adam spoke of the "tiny breasts of young girls and the nacreous whiteness of their soft skins." As for Félix Fénéon, he said that this work "puts to shame the nudes we remember from galleries and legend."

In reply to Octave Maus, who asked Seurat what price he was setting for the large version of *The Models*, the artist wrote that it would have to include his living expenses for one year at seven francs a day.

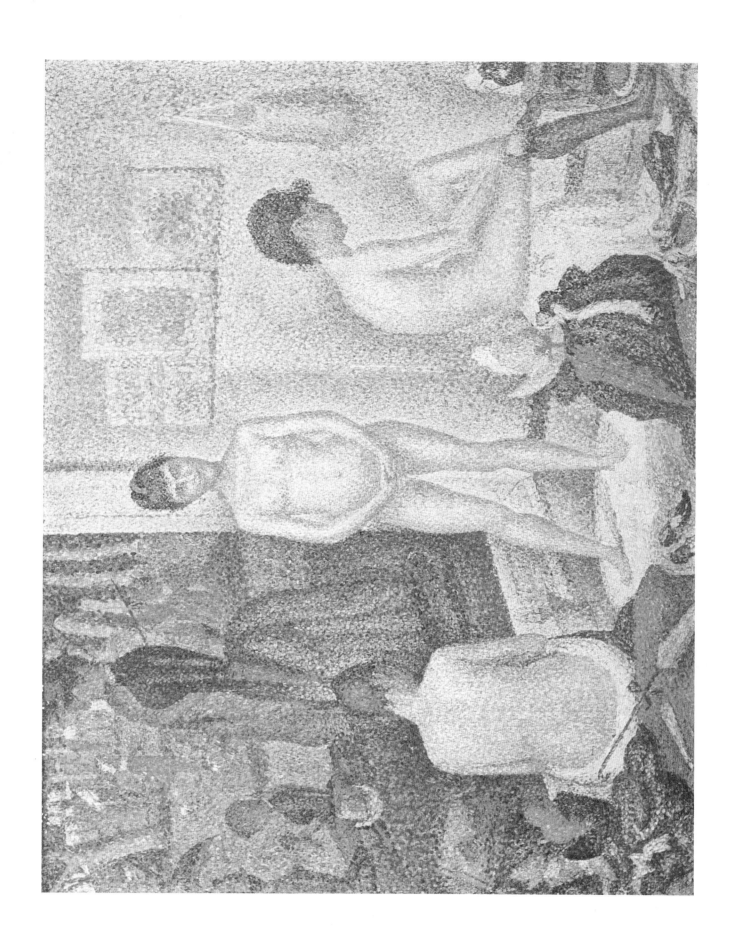

Painted 1887

STUDY FOR "THE SIDE SHOW"

Oil on panel, 6 3/8 × 10 1/4". Unsigned

Collection Emil Bührle, Zurich

This is the small study which in the end led to *The Side Show*. The straight lines dividing the panel are still visible. In one sense, it is already complete, for it gives off light like tinsel on a Christmas tree. It fairly sizzles and crackles.

Seurat gave a great deal of thought to the organization of this picture. He drew many groups of dancers, clowns, a dancer resting, shivering inside the cloak thrown over her shoulders, groups of spectators under a stunted boulevard tree, and idlers held spellbound by the side show barkers.

So far as the subject is concerned, Seurat had one great precursor—Daumier. The latter's *Mountebank's Side Show* is set in daylight and is impetuous in its dynamism. Seurat's painting is very different: it represents an uncomplicated, routine carnival performance under artificial light, the kind that exudes bored professionalism, where the laughs are forced, played to a scattering of onlookers.

Originally Seurat planned to show a woman in profile (he made a drawing of her) instead of the ringmaster with the riding crop.

Painted 1888

THE SIDE SHOW (LA PARADE)

Oil on canvas, 39 3/4 × 59 1/8". Unsigned

The Metropolitan Museum of Art, New York. Bequest of Stephen C. Clark, 1960

After the outdoor light of *La Grande Jatte* and the studio light of *The Models*, here is artificial light; the gas and acetylene lamps create the mood of traveling fairs.

This work shows to what extent Seurat was concerned with construction. It is clear here how deeply Seurat had been impressed by David Sutter's observations on the architectonics of classical works of art. The canvas analyzes itself, as it were. It would be pedantic nowadays to trace the counterpoint of verticals and horizontals, clear-cut rectangles and blurred ovals, the whole broken by a few slanting lines (the branches of the tree, the ringmaster's riding crop, the railing of the staircase behind the trombone player at the center).

This is perhaps the sole work of nineteenth-century painting that unequivocally anticipates Cubism (and even Purism). It heralds the coming of a new school, which, from 1908 on, was to revolutionize form no less profoundly than Seurat revolutionized the treatment of color.

Seurat here is at his coldest and most austere. It would seem that the balance of *La Grande Jatte* and *The Models* has given way to excessive deliberateness. We may say that like certain works by Poussin, *The Side Show* is a painting which has been wholly thought out in advance.

The face of the ringmaster (or perhaps animal trainer), with the same haircut and mustache twisted to turn up, will reappear in *Le Chahut*, where the riding crop is replaced by a conductor's baton.

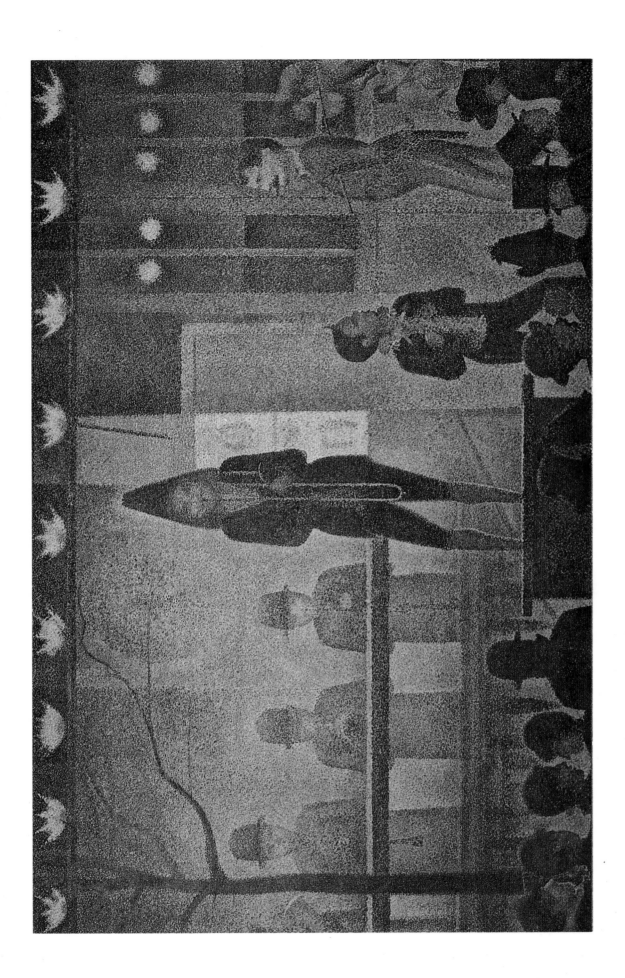

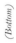

(Bottom)

Painted 1888

PORT-EN-BESSIN

Oil on canvas, 26 3/8 × 33 1/4". Signed, bottom right
The Minneapolis Institute of Art. The William Hood Dunwoody Fund

This landscape is one of Seurat's more austere works, one that again reveals him to have been an ancestor of so-called abstract art.

A scene with as many things in it as this (bridge, houses, breakwater, pavilion, people) demands as much of an academic layout as a "picture that tells a story." No doubt that was what induced Seurat to paint this "composed landscape" under a relentless summer sun, clouds roiling in the heat.

Félix Fénéon pointed out how stiff and affected the painting is, but he ascribed this defect to the presence of the human figures. "We should like the figures shown walking on the quay at Port-en-Bessin to be less stiff," he wrote in *L'Art Moderne* (October 27, 1889). He recognized, however, that the child was charming. Actually, the little girl facing the viewer is the only poetic note in a painting otherwise positively "steely."

Signac had painted at Port-en-Bessin in 1882 and 1883, and it was he who suggested the site to Seurat when they met in 1884. The latter painted six canvases there in 1888, in rapid succession.

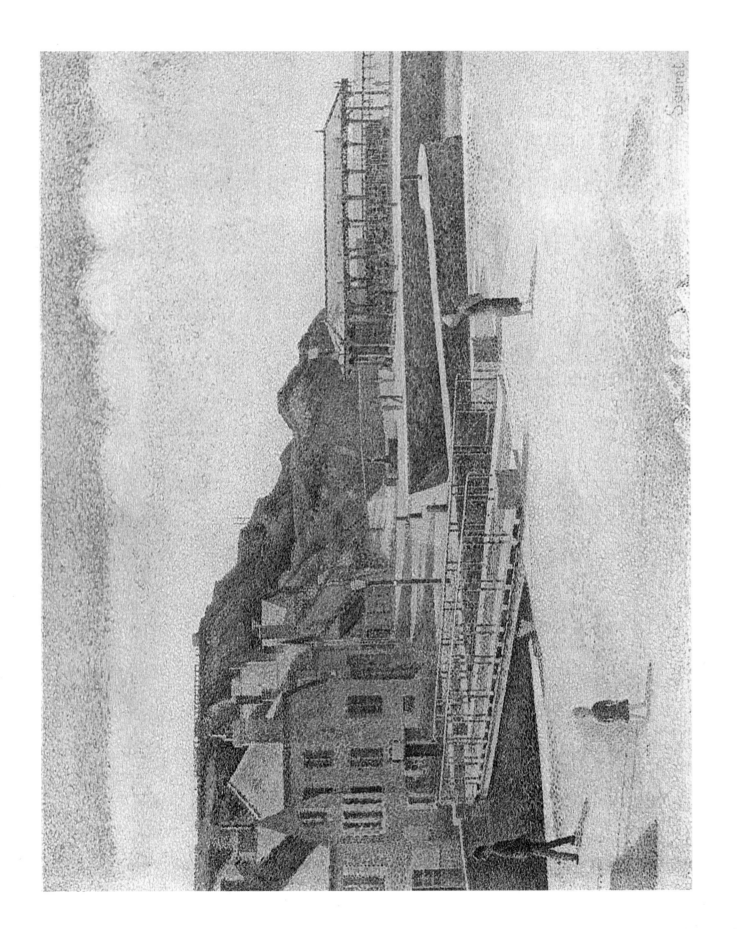

Painted 1888

LOADING HOIST AT THE WATER GAP, PORT-EN-BESSIN

Oil on canvas, 25 1/2 × 31 3/4". Signed, bottom right

Collection Mrs. W. Averell Harriman, New York

This is one of Seurat's most varied and sweeping landscapes, a contrast between sea and sky, heaviness and fluidity, under fringes of curlicue clouds. The steep drop of the land to the sea forms a diagonal that cuts across the picture from top left to bottom right.

The over-all effect is rather baroque. The curve dominates. The only horizontal features are the line of coast and the sea across the horizon.

The dot technique admirably suggests the vegetation on the cliff. The two verticals at top left give the painting its dramatic appearance, and despite their seeming fragility in this landscape, it is from them that the painting has derived its title.

The pigment is compact, sonorous, very varied in treatment. The dots, big in the foreground, get tinier and tinier on the sea as they move away from us. The ray of sunshine on the dune at right amid encroaching shadow adds a note of joy.

César de Hauke tells us why Seurat's signature on this work is barely legible. "Seurat painted the border of this canvas after it had already been signed. He had made a painted border before doing so, then decided minor retouching was needed still. This was how his own signature got partially painted over."

The work was acquired by Fénéon from Seurat's mother.

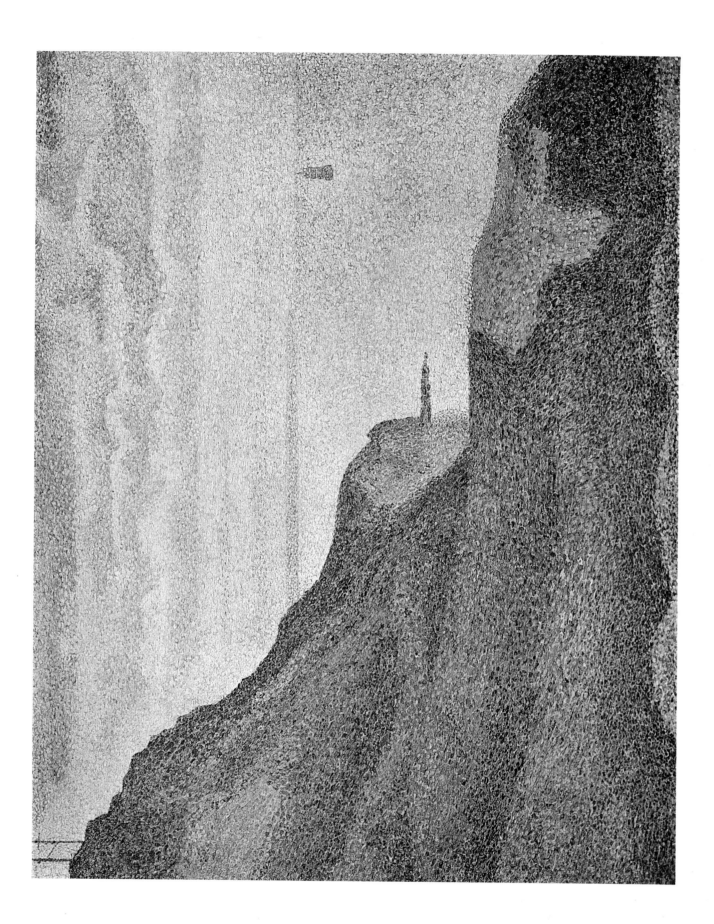

(*Bottom*)

Painted 1888

FISHING FLEET
AT PORT-EN-BESSIN

Oil on canvas, 21 5/8 × 25 3/8". Unsigned

The Museum of Modern Art, New York. Lillie P. Bliss Collection

This restful view is a kind of watery maze with boats circling around the breakwaters in the heat of a bright summer day. The canvas is divided into two compartments. A fairly heavy triangular strip of land forms the foreground, while above it dynamic bands of light suggest the breeze swelling the sails and sweeping the sea over which sailboats are gliding in every direction.

In this limpid work Seurat is especially effective at evoking boats moving toward the horizon. This endows the painting with infinite depth in space.

According to César de Hauke, Seurat exhibited this work in 1888 under the title *The Jetties at Port-en-Bessin*. Exhibiting it again the following year, he gave it the title by which it is known today. After Seurat's death, however, his family exhibited it twice under the title *Port-en-Bessin, The Outer Harbor at High Tide*, which is actually the title of another painting, now in The Louvre.

In *Transformations*, Roger Fry points out the surprising beauty of the shadows the clouds cast on the sea, forming a subtle arabesque whose fluidity is further accentuated by the patterns of vegetation in the foreground.

Painted 1888

PORT-EN-BESSIN,
THE OUTER HARBOR AT LOW TIDE

Oil on canvas, 21 1/8 × 25 7/8". Signed, bottom left
The Saint Louis Art Museum

The sea has receded and with it its assault against dry land has been temporarily removed. In front of the stone breakwater and the houses a slimy tidal flat has been exposed. Though full of life, this is the sea in its least impressive aspect.

What is given here is another of those great silences Seurat was so good at expressing in his landscapes. It communicates tranquillity and, like others of them, fills the viewer with a kind of contentment. The absence of people has something to do with this.

The work shown here is built up in horizontal layers—the sea wall, the breakwaters, the horizon line, the sky.

This is a delicate work more nearly suggested than stated, perhaps even a bit understated, but the colors and tonalities have persuasive charm. With his Pointillist technique (even the signature is "beaded"), Seurat succeeds in giving universality to his subject, objectifying it enough so that we forget, not the name of the place (he was anxious to remind us of it), but any too narrowly regional associations. The work might as aptly, or perhaps even more aptly, be titled "Low Tide."

The painting was exhibited at the Indépendants in 1890. The Belgian painter Théo van Rysselberghe owned it for a time, and later Charles Pacquement.

116

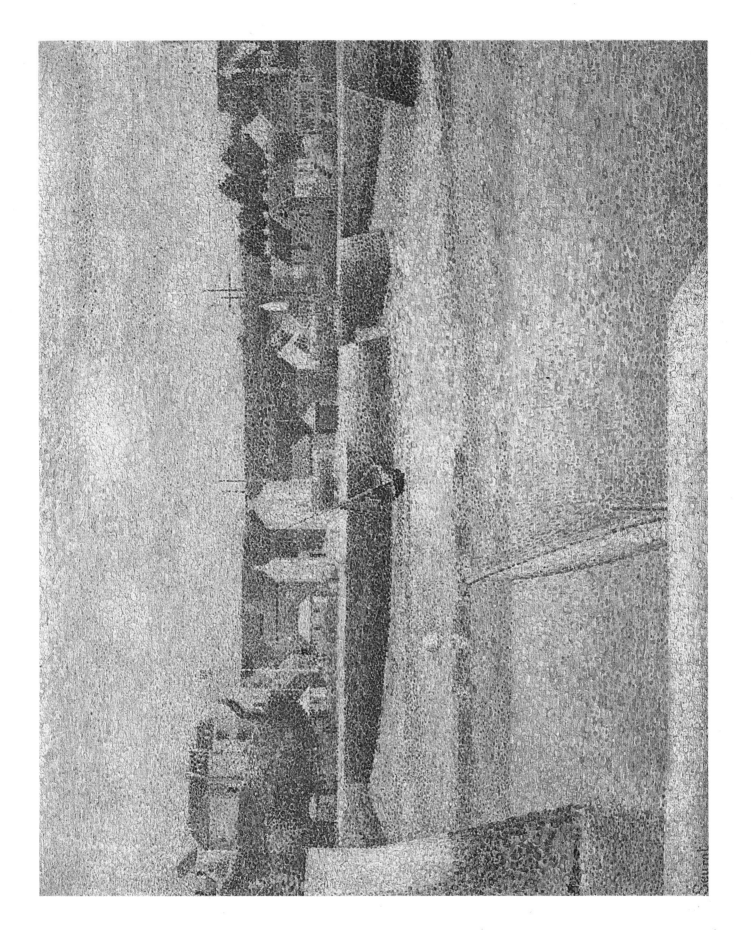

Painted 1889

THE EIFFEL TOWER

Oil on panel, 9 1/2 × 6″. Unsigned

Collection Mr. and Mrs. Germain Seligman, New York

According to Gustave Coquiot, this work was painted in 1890, the year after the tower was opened for the Paris World's Fair—at which it provided the main attraction. Completed on March 31, 1889, the tower is 984 feet tall and is composed of 12,000 metal parts held in place by 2,500,000 rivets.

Impressed by the intricate calculations involved in this piece of architectural engineering, no doubt also indulging his fondness for the vertical, Seurat shows us the tower from across the Pont d'Iéna, soaring into a sky spangled with vibrant dots. This is a tribute to "the great lady" who, at the time, made the public uneasy. Two years before its completion a number of writers protested, among them J.-K. Huysmans, who called it "the spire of a junkyard Notre Dame."

Here Seurat's dots are rounded, like so much blue and orange confetti. They are running in every direction, up, down, making circular swirls and contrapuntal contrasts. The work is fresh, highly colorful, firmly set against the Paris sky—Seurat's sky.

Speaking of an exhibit of panels and drawings by Seurat, Signac wrote in his diary for February 22, 1895: "These . . . painterly thoughts give off a certain magic."

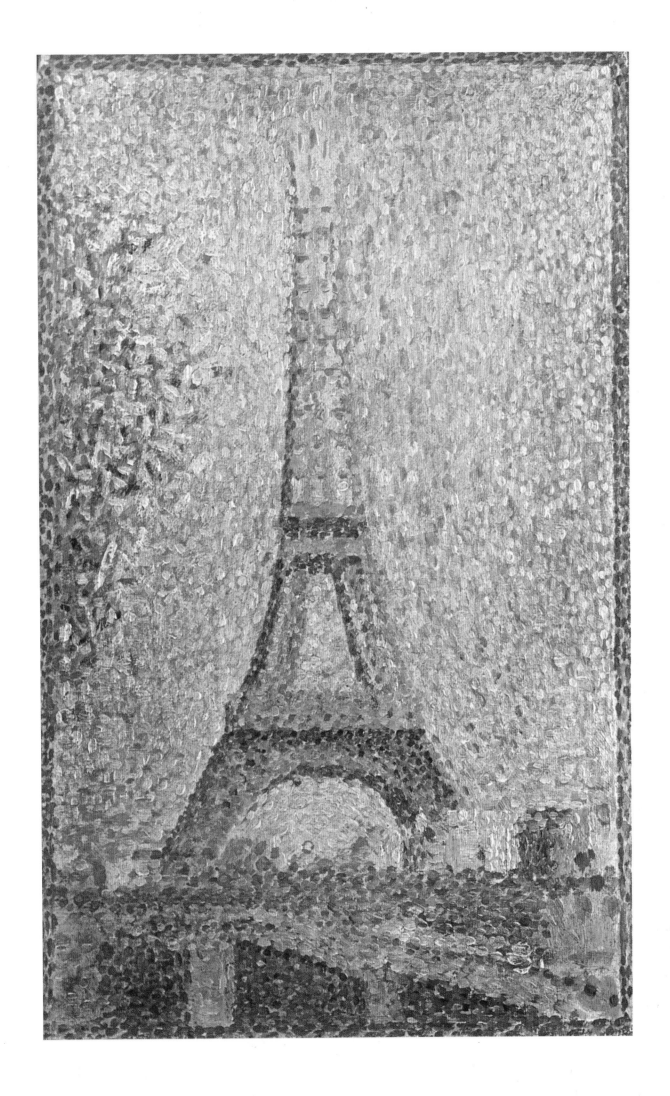

Painted 1890

YOUNG WOMAN
POWDERING HERSELF

Oil on canvas, 37 1/2 × 31 1/4". Signed, bottom left
Courtauld Institute of Art, The Home House Trustees, London

This is a portrait of Madeleine Knoblock, Seurat's mistress. There is an atypical squalidness about this canvas, which could almost be a scene in a gypsy wagon. Instead of the vase with flowers seen between the two panels of the folding mirror on the wall, Seurat had first painted his own portrait. When a friend who saw it told him it made him look silly, Seurat covered his face with the flower pot.

As for the plump model, she brings to mind the circus and carnival people and the music-hall artistes Seurat was seeing so much of at the time (he often went to the Gaîté Rochechouart and the Eden Concert). Perhaps Seurat wanted to show us his lady friend in her habitual surroundings—corseted like a traveling player, dressed in organdy, with heavy bracelets and a pink hair-ribbon of the kind we see attached to the round mirror on that horrible little table.

The painting belonged to Madeleine Knoblock. It is interesting to compare it with the drawing *The Artist's Dressing Room* of about 1887, in which we find this same atmosphere of backstage at a carnival or circus.

Of all the critics who have written on Seurat, only Roger Fry expressed surprise at the model's "grotesque dishabille."

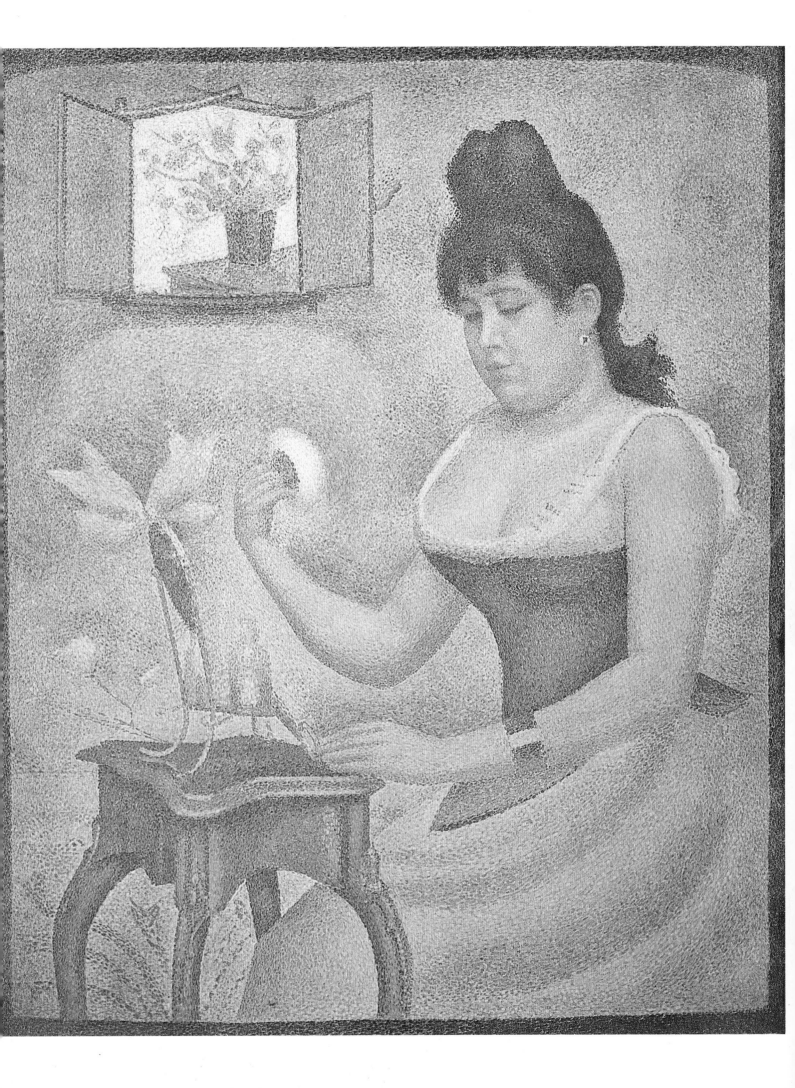

Painted 1890

PORT OF GRAVELINES

Oil on canvas, 28 3/4 × 36 1/2". Signed, bottom right
The Indianapolis Museum of Art. Gift in memory of Daniel W. and Elizabeth C. Marmon

This is a canvas that presents in one compact vision the air of the harbor and of the sea. An impression of stability is supplied by the bollards along the sea wall casting their shadows in the direction of the channel. The rest is infinity, the infinity of a perspective in an elegant parabola, seemingly a prelude to the immensity of the sea, here perfectly calm and inducing to calm. The free, full, modulated space which cuts the painting in two gives off utter serenity: the lighthouse, the boats at anchor, and the harbor cut across by one sweeping diagonal to provide the contrasting movement.

This painting is luminous, flooded with light and sunshine, rather high in color; it contrasts with the evening effect of the channel scene in the William A. M. Burden collection.

As Lucie Cousturier observed of Seurat, "He could sit down in front of any bench, tree, or wall which others had previously depicted, and his own vision would not be influenced one particle."

The canvas was exhibited at the Exposition des XX in Brussels, and at the Indépendants of 1891 with *The Circus*. There exists one study for it on a panel which was owned by Maximilien Luce.

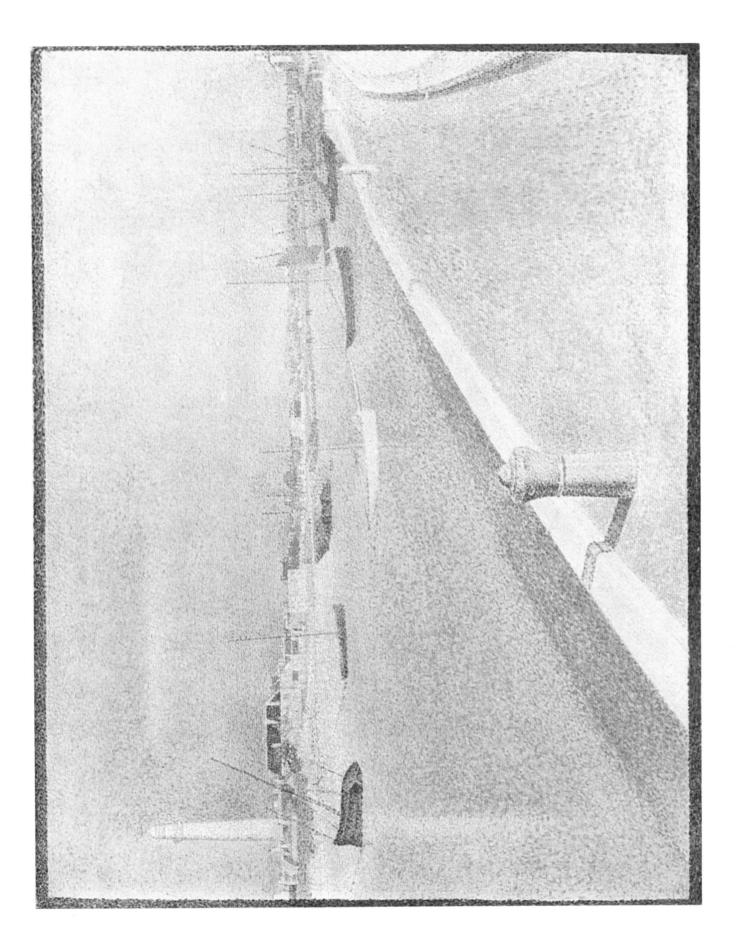

Painted 1890

THE CHANNEL AT GRAVELINES, EVENING

Oil on canvas, 25 3/4 × 32 1/4″. Unsigned

Collection William A. M. Burden, New York

This late work (it was exhibited at the Indépendants with *The Circus* in 1891) may be looked upon as Seurat's last will and testament so far as landscape is concerned. What silence, what peace these forms, simplified by the approach of night, suggest! At left, the lamppost reminds us of Seurat's fondness for the vertical. In the channel we are slipping away into the somnolence that comes at dusk after a day's sailing.

This is peace, the calm after storm. In the sky, clouds fringed by one last glow are moving slowly and dissolving gradually into the vast dark. But what endows the canvas with such poetry are the anchors silhouetted at the right—symbols of repose, of immobilization (but not of immobility). The anchors suggest that the last of the daylight will shortly be snuffed out, that night is falling, that all things pass, and that our eyes will soon close in sleep.

For Seurat it will shortly be the last sleep, and this painting could almost have been a premonition.

A tremendous gift for synthesis was required to give form to such a great vision, to fill a canvas with so few elements, all concentrated in silhouette, with the dark accents of the lamppost and the anchors, which open up the painting to the vast space it encompasses.

The painting once had a wide, flat frame, which Seurat painted himself and which may have borne his signature, but it has since disappeared.

This work was owned by Madeleine Knoblock and later by Théo van Rysselberghe. According to Robert L. Herbert, van Rysselberghe's mother-in-law sent four hundred francs to Seurat's mistress in payment for the picture.

124

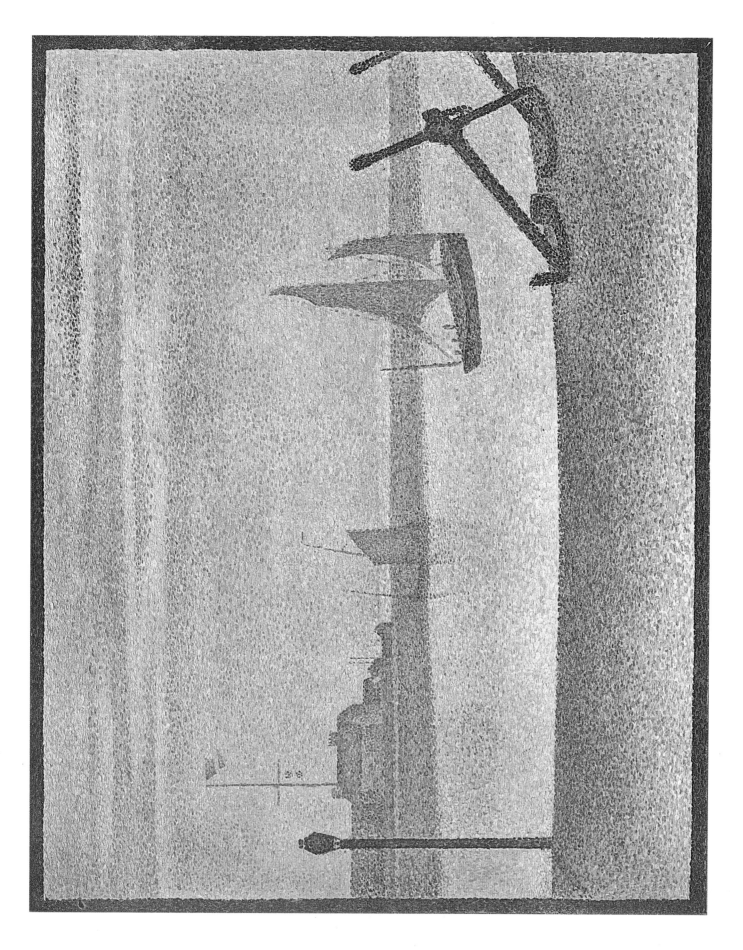

Painted 1891

THE CIRCUS

Oil on canvas, 73 × 59 1/8". Unsigned

Musée d'Orsay, Paris

This is beyond any question the most baroque work Seurat ever painted. The unfinished canvas is composed of circles, spirals, and ellipses. Exceptionally, it is built up on horizontals with the entrance to the ring at the right the only vertical break.

Seurat was fond of novels by the Goncourt brothers, and here gives us a visual counterpart to the *Frères Zemgano*, a tale about the circus. Lucie Cousturier wrote that the composition "sets itself the aim of holding within one sweeping curve all the upward-running lines denoting circus fun and games." The movement from right to left, that of the lady bareback rider who, "a modern goddess of grace and freedom," is doing acrobatics on the white horse, is counterpoised by the movement of the clown in the center with the garish wig, who arises perpendicularly from the foreground.

The figure in the first row of seats, with a silk hat and a peak of hair visible under it, is the painter Charles Angrand, a friend of Seurat's.

This work was exhibited in its unfinished state at the seventh Salon des Indépendants, from March 20 to April 27, 1891. Seurat died during the exhibition.

The Circus is almost a plagiarism. Robert L. Herbert—who has pointed out similarities between certain of Chéret's posters and Seurat's compositions—proves that the clown doing a back-flip in *The Circus* is identical (only reversed) with one in a poster by Chéret of 1880, executed for the Spectacle-Promenade de l'Horloge in the Champs-Élysées. (Chéret also was acquainted with the works of Rood and Chevreul.) As for the over-all design, Meyer Schapiro has proved that Seurat took it from an anonymous poster for the Nouveau Cirque, printed in 1888, reversing the horse and the bareback rider. But the drawing in that poster bears no comparison with Seurat's painting—it is heavy, clumsy, the horse moves sluggishly, the rider is ungraceful—whereas in Seurat everything gallops and cavorts.

The layout of this painting almost seems to have been done by some mechanical process, a tracing in blue. That we can even think this is no doubt accounted for by its unfinished state, as Fénéon suggested in a letter where he gave it as his opinion that *The Circus* is finished only "so far as the background is concerned (rows of spectators merely indicated in blue)."

Seurat painted the flat frame for the painting, and it bears his signature.

Signac, who was able to purchase the picture quite cheaply, noted in his diary: "Seurat's family, though very well off, is selling everything."

126

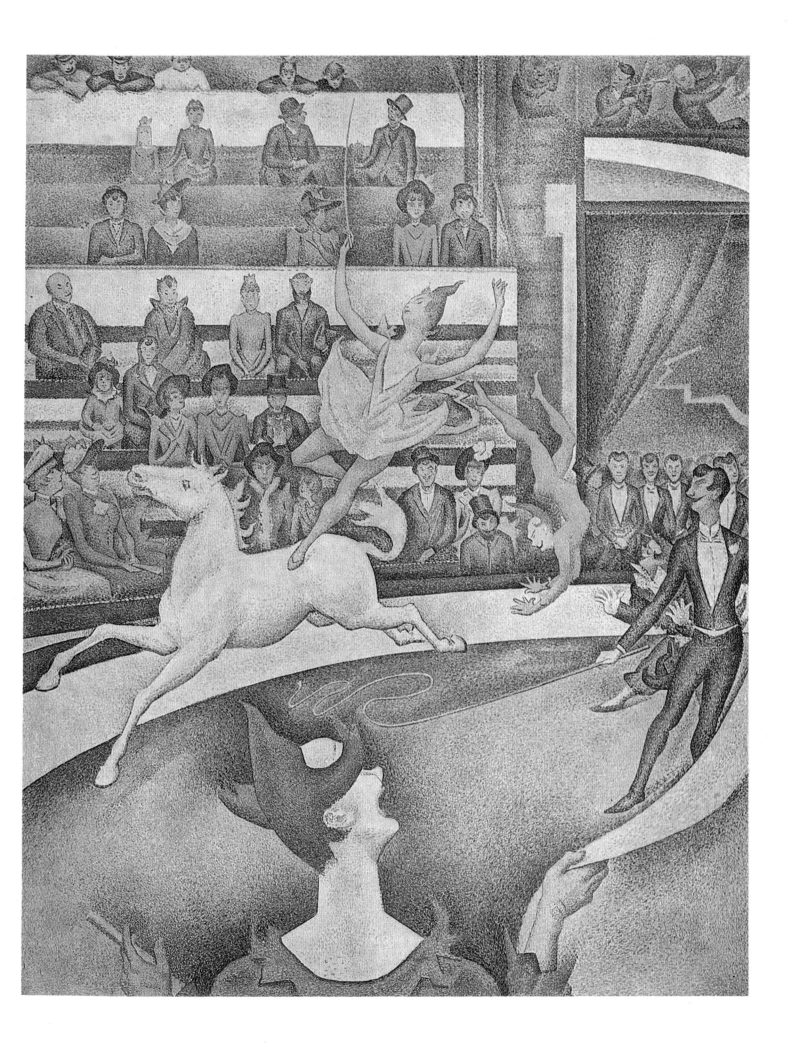

SELECTED BIBLIOGRAPHY

ALEXANDRE, A., "Chroniques d'aujourd'hui: un vaillant," *Paris*, April 1, 1891.

CHASTEL, A., "Une source oubliée de Seurat," *Études et Documents sur l'art français*, XXII, 1950–57 [1959], pp. 400 ff.

CHRISTOPHE, J., "Chromo-luminaristes—Georges Seurat," *La Plume*, September 1, 1889, supplement, p. 292.

———, "Seurat," *Les Hommes d'aujourd'hui*, VIII, n. 368, n.d. [published March-April, 1890]

COGNIAT, R., *Seurat*, Paris, n.d. [c. 1950]

COQUIOT, G., *Les Indépendants, 1884–1920*, Paris, 1920.

———, *Georges Seurat*, Paris, 1924.

COUSTURIER, L., *Georges Seurat*, Paris, 1921; more fully illustrated edition Paris, 1926.

DORRA, H., and REWALD, J., *Seurat*, Paris, 1959.

FÉNÉON, F., *Les Impressionnistes en 1886*, Paris, 1886.

———, "Notes inédites de Seurat sur Delacroix," *Bulletin de la Vie Artistique*, April 1, 1922.

———, "Précisions concernant Seurat," *Bulletin de la Vie Artistique*, August 15, 1924.

———, "Georges Seurat und die Öffentliche Meinung," *Der Querschnitt*, October, 1926, p . 767 ff.

———, *Oeuvres*, Paris, 1948.

FRY, R., "Seurat's 'La Parade,'" *Burlington Magazine*, LV, December, 1929, pp. 289 ff.

GEORGE, W., *Seurat*, Paris, 1928.

GERMAIN, A., "Théorie chromo-luminariste," *La Plume*, September 1, 1891, pp. 285 ff.

HAUKE, C. DE, *Seurat et son oeuvre*, 2 vols., Paris, 1961.

HERBERT, R. L., "Seurat and Chéret," *Art Bulletin*, XL, June, 1958, pp. 156 ff.

———, "Seurat and Puvis de Chavannes," *Yale University Art Gallery Bulletin*, XXV, October, 1959, pp. 22 ff.

———, "Seurat and Émile Verhaeren: Unpublished Letters," *Gazette des Beaux-Arts*, LIV, December, 1959, pp. 315 ff.

———, *Seurat's Drawings*, New York, 1962.

HOMER, W. I., "Seurat's Port-en-Bessin," *Minneapolis Institute of Arts Bulletin*, XLVI, Summer, 1957, pp. 17 ff.

———, "Seurat's Formative Period—1880–1884," *The Connoisseur*, CXLII, August, 1958, pp. 58 ff.

———, "Notes on Seurat's Palette," *Burlington Magazine*, CI, May, 1959, pp. 192 f.

———, *Seurat and the Science of Painting*, Cambridge, Mass., 1964.

LÖVGREN, S., *The Genesis of Modernism: Seurat, Gauguin, Van Gogh and French Symbolism in the 1880's*, Stockholm, 1959.

LHOTE, A., *Georges Seurat*, Rome, 1922.

———, *Seurat*, Paris, 1948.

NATANSON, T., "Un primitif d'aujourd'hui—Georges Seurat," *La Revue Blanche*, April 15, 1900, pp. 609 ff.

PACH, W., *Georges Seurat*, New York, 1923.

REWALD, J., *Georges Seurat*, New York, 1943.

———, "Seurat: The Meaning of the Dots," *Art News*, XLVIII, April, 1949, pp. 24 ff.

———, *History of Impressionism*, New York, 1946; revised and enlarged edition New York, 1961.

———, *Post-Impressionism—From Van Gogh to Gauguin*, New York, 1956; second edition New York, 1962.

REWALD, J. (ed.), "Extraits du journal inédit de Paul Signac, I (1894–95)," *Gazette des Beaux-Arts*, XXXVI, July-September, 1949, pp. 97 ff.

———, "Extraits du journal inédit de Paul Signac, II (1897–98)," *Gazette des Beaux-Arts*, XXXIX, April, 1952, pp. 265 ff.

———, "Extraits du journal inédit de Paul Signac, III (1898–99)," *Gazette des Beaux-Arts*, XLII, July-August, 1953, pp. 27 ff.

———, "Seurat and His Friends" (introduction to the catalogue of an exhibition at the Wildenstein Galleries), New York, 1955.

See also DORRA, H., and REWALD, J.

RICH, D. C., *Seurat and the Evolution of "La Grande Jatte,"* Chicago, 1935.

RICH, D. C. (ed.), *Seurat: Paintings and Drawings* (exhibition catalogue), Chicago and New York, 1958.

ROOKMAKER, H. R., *Synthetist Art Theories*, Amsterdam, 1959.

SALMON, A., *La Révélation de Seurat*, Brussels, 1921; republished in *Propos d'atelier*, Paris, 1922.

SCHAPIRO, M., "Seurat and 'La Grande Jatte,'" *Columbia Review*, November, 1935, pp. 9 ff.

———, "New Light on Seurat," *Art News*, LVII, April, 1959, pp. 22 f; pp. 44 f; p. 52.

SELIGMAN, G., *The Drawings of Georges Seurat*, New York, 1947.

SIGNAC, P., *D'Eugène Delacroix au Néo-Impressionnisme*, Paris, 1899; second edition 1911; republished 1964 with an introduction by F. Cachin.

———, "Le Néo-impressionnisme—Documents," *Gazette des Beaux-Arts*, XI, January, 1934, pp. 49 ff.

VENTURI, L., "The Art of Seurat," *Gazette des Beaux-Arts*, XXVI, July-December, 1944, pp. 421 ff.

———, "Piero della Francesca, Seurat, Gris," *Diogenes*, Spring, 1953.

VERHAEREN, E., "Notes, Georges Seurat," *Nouvelle Revue Française*, February 1, 1909, p. 92.

WEBSTER, J. C., "The Technique of Impressionism; a Reappraisal," *College Art Journal*, IV, November, 1944, pp. 3 ff.

WILENSKI, R. H., *Seurat*, London, 1949.

ZERVOS, C., "Un Dimanche à La Grande Jatte et la technique de Seurat," *Cahiers d'art*, n. 9, 1928, pp. 361 ff.